Musée d'Orsay

100 IMPRESSIONIST
MASTERPIECES

Musée d'Orsay

100 IMPRESSIONIST
MASTERPIECES

LAURENCE **MADELINE**

EDITIONS SCALA

Photographic credits

© Réunion des Musées Nationaux, Paris: pp. 28, 53, 123-3, 130, 131, 134, 135, Photo Arnaudet: pp. 40, 41. Photo M. Bellot: p. 21. Photo J. G. Berizzi: p. 138. Photo P. Bernard: pp. 33, 84b. Photo C. Jean: pp. 119, 120, 121. Photo H. Lewandowski: cover and pp. 6, 13, 18, 19, 20b, 22 to 24, 26, 27, 29 to 32, 34 to 38, 42, 43, 45, 48 to 52, 54, 55, 64, 66, 68b, 69 to 71, 72t, 73t, 74 à 83, 84t, 85t, 88, 90 to 93, 97, 100 à 107, 114, 115, 118, 122, 123-2, 123-4, 123-5, 124 to 127, 129, 132b, 133, 136, 137. Photo P. Néri: p. 85b. Photo R. G. Ojeda : pp. 25b, 62, 63, 65, 68t, 73b, 96t, 128. © Éditions Scala: pp. 20t, 25t, 39, 44, 46, 47, 57, 67, 72b, 86, 87, 89, 94, 95, 96b, 98, 99, 109, 116, 117, 132t.

■ © 1999, **Éditions Scala**
Passage Lhomme
26 rue de Charonne - 75011 Paris
All rights reserved.
■ Translation
Margaret **Rocques**
■ Graphic design
delepière**damour**
■ Copy-editing
Alexandra **Keens**

Contents

7 ■ INTRODUCTION

12 ■ IMPRESSIONISM **FROM 1863 TO 1874**
FRIENDS IN CONVERSATION
A BREAK WITH TRADITION
A NEW WORLD
PORTRAITS
OPEN-AIR PAINTING

56 ■ IMPRESSIONISM **FROM 1874 TO 1886**
THE PLEASURES OF THE DAY
REBUILDING THE LANDSCAPE
MODERN LIFE
HISTORICAL PAINTING

108 ■ IMPRESSIONISM **AFTER 1886**
SISLEY, IMPRESSIONISM PRESERVED
PISSARRO, THE LAST BATTLES
RENOIR, THE PLEASURE OF PAINTING
MONET, THE TRIUMPH OF THE LANDSCAPE
CÉZANNE, THE ESSENCE OF THINGS
DEGAS, REFUSING THE EASY WAY
MONET, PRIMORDIAL NATURE

139 ■ BIOGRAPHIES

143 ■ CHRONOLOGY

144 ■ LIST OF ILLUSTRATIONS

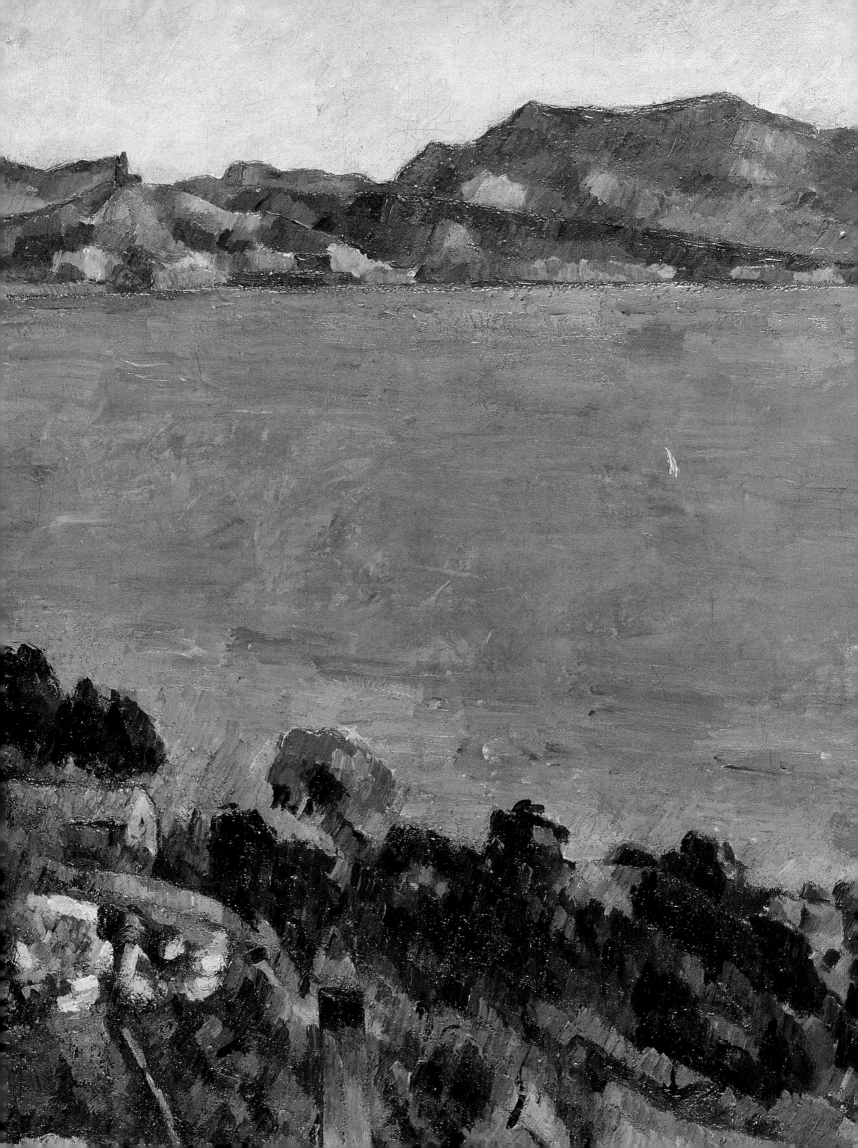

Introduction

■

■ *"They were going to be given a name, something*
■ *they had so far been lacking..."* Duret

■

"They are like little fragmented images of everyday life, and the subtle, fleeting, colourful and charming things reflected in them are worthy of our attention and celebration…". These friendly words, at once so appropriate and so heartfelt, penned by the critic Philippe Burty in 1875, constitute a definition of Impressionism that visitors to the museum and other admirers of the movement will freely and gladly subscribe to. Indeed, how can we not celebrate the paintings of Monet, Pissarro, Cézanne, Renoir and Sisley, which, in the museum's upper gallery, distil on their colourful surfaces images of a world that is already our own but that we see in all its idyllic, youthful freshness. The first and most powerful charm of Impressionist painting lies in its clear and luminous rendering of the infancy of the modern era – the fleecy plume of smoke from a steam engine setting off into an azure sky, the frilly dress after a creation of Worth's, the hurrying crowds of the boulevards and smartly dressed crowds of the races and regattas, the flickering glow of a streetlight, sun-filled gardens, the remains of a family lunch and the terrace of a Parisian café – a positive world we can believe in.

Yet Impressionism was made up of revolutions, tensions and inventions and it has kept its charm because of the strong styles it introduced. With its powerful black and triumphant colour, bold compositions, new view of perspective and rejection of drawing as the only means of constructing pictures, Impressionism broke with all the conventions of the day. The word Impressionism was coined too soon and has all the shortcomings and flaws of a quip. It first saw the light of day in a throwaway remark of a malicious rather than a witty nature made by Louis Leroy, the entertaining columnist of *Charivari*, to a readership hungry for sarcasm. Its target was Monet's painting, *Impression, soleil levant* (*Impression, Sunrise*) (Paris, musée Marmottan-Monet) that was shown at the first exhibition of the "Company of artists, sculptors and engravers, etc.", which opened its doors on 15th April 1874 in the studio of the photographer Nadar, boulevard des Capucines. "Yes, definitely an impression. Then I said to myself, if I'm impressed, it must be impressive…," wrote Leroy. The hitherto anonymous movement was thus given a name and marked with the seal of incomprehension and rejection. Whether they accepted or rejected the epithet, the painters sought always to minimise its importance,

refusing to allow themselves to be so quickly labelled and insisting on their individuality. What was Impressionism, then? According to Renoir, it was a group of painters who "did not want to see painting decline irrevocably" and wanted "to relearn a forgotten skill...". For Degas, the word did not exist and he only recognised the terms realist, independent, intransigent and even insurgent. Monet, for his part, accepted the term but "was very sorry to have been the cause of a name given to a group most of whose members were not in the least Impressionist". The Impressionist movement is defined by three attitudes that emerge from declarations made by the various members of the group.

The first attitude stresses the importance of impressions. We will leave it Monet to relate the genesis of the title of the founding painting, *Impression, soleil levant*: "I had sent something I had painted from my window in Le Havre, misty sunlight with a few ships' masts emerging in the foreground... It really could not pass for a view of Le Havre, so when I was asked to give a title for the catalogue, I answered, "Put *Impression.*" Although Monet's choice was a spontaneous one, it was not coincidental and the coining of the term "impression" is not surprising. Monet fully accepted the unfinished aspect of his view of Le Havre when he presented it to the public. He also asserted the primacy of his eye and vision over all the traditional artistic principles and dogmas. Finally, he adopted the legacy of the landscape painters of the Barbizon school, such as Daubigny, who was already using the word impression, and followed the example of Whistler, who had been calling his paintings *Harmonie (Harmony)...*, *Variation...* or *Arrangement...* since the late 1860s. Most of the critics of the 1874 exhibition were struck, if not shocked, by both the title of Monet's painting and by the unfinished appearance of most of the pictures in the exhibition. "Thus what really separates them from their predecessors is a question of finish," noted Castagnary in 1874, while Cézanne the same year confessed: "I constantly have to strive not to achieve the finished appearance admired by fools. The thing that is so commonly admired is merely unskilled labour. Any painting resulting from it is inartistic and banal." While Monet, Degas, Cézanne, Pissarro and Renoir were reluctant to use the term Impressionism, they all used the word impression, which translated the force of their gaze and sensibility and situated

the originality of this sensibility and their painterly temperament just between the motif and the work. As Cézanne wrote: "The most seductive thing about art is the personality of the artist himself." Yet the champion of Impressionism and its involuntary father remained Monet, as the critic Duret recognised in 1878: "If the word Impressionist has been found apt and permanently adopted to designate a group of painters, it is certainly the particular characteristics of Monet's painting that first suggested it. Monet was the quintessential Impressionist."

The second attitude is realism. This was probably the term preferred by Degas. Absorbed in the preparations for the first exhibition, he wrote in March 1874 to his friend, the painter James Tissot: "I'm very active, I'm working hard at it and, I believe, with a fair amount of success... The realist movement no longer has to struggle with the rest. It has come into being and exists and must show itself to be a thing apart. There must be a realist Salon." Degas never saw himself as an Impressionist and fought ardently to defend "the great cause of realism". If all the painters, sculptors and engravers who exhibited together from 1874 onwards were realists, dealing exclusively with subjects taken from the reality of their times, only Degas claimed the expression of reality as the end of his art.

The third attitude was independence and intransigence. Behind these two words we yet again find Degas, ready to get angry, lose his temper and invent strict rules to preserve intact the movement's rejection of artistic institutions. For the Impressionist movement was born of a struggle that had started a few years earlier against the upholders of the artistic establishment, as Monet reminds us: "My friends and I had been systematically refused by the jury for some time. What were we to do? You don't just have to paint, you have to sell your work to live. The dealers didn't want us. Yet we had to exhibit. But where? We wondered if we should we hire a hall... Nadar, the great Nadar, who is a very kind man, lent us a place, and we then made ... our appearance in the artistic firmament as independent stars." Impressionism united painters who realised they could no longer rely on the State for their careers, who decided to exhibit outside the Salon, to refuse the sanction of the jury as well as its rewards, to force the attention of the critics and to go and find potential clients. Courbet and later Manet had already attempted

this alone. In 1855, Courbet had shown most of his paintings grouped around the *Atelier* (*Studio*), that had been refused by the jury of the Universal Exhibition, in "The Pavilion of Realism". In 1867, he had done it again and had been imitated by Manet, who was tired of the persecution of the juries and critics. Yet the decision taken by the Impressionists was a small revolution that established the independence of both art and artists. Despite the promising innovation of the secessionist exhibition of 1874, Monet, Degas and their friends still had to go on fighting the old demons of the Salon and its visitors. They were tenacious demons that tempted Manet, who failed to join his young friends and instead sought recognition in the very place where he had so often been denigrated, as well as Monet, who exhibited at the 1880 Salon, Renoir who triumphed through his talents as a portrait painter, and even Cézanne, who regularly sent a painting to the Salon out of mockery or defiance. Impressionism was not the undifferentiated movement despised by a few critics. It was an instrument of survival and promotion in a hostile artistic environment, a cold, hard world that did not yet understand all the beauty, grandeur and anxiety of its time. It was a movement made up of great artists who were developing, sometimes side by side, in the early years, mostly alone, who, according to their sensitivity to the world about them, were tapping veins that even today still flow. It was these great artists and the paths they took that the musée d'Orsay presents to us and that we shall meet in the following pages. Their relationships and friendships can be seen in the first rooms of the museum. The great Bazille, the first patron of the newly emerged Impressionism, painted his friend Monet in *L'Ambulance improvisée* (*The Improvised Ambulance*) and was in turn painted by Renoir at his easel. With *L'Atelier de la rue de la Condamine* (*The Studio in the Rue de la Condamine*), Bazille established forthright friendship as the group's keynote. *La Famille Bellelli* (*The Bellelli Family*) by Degas, with its classical references steeped in Italianism, is in contrast with the pastoral flights of Monet who, in the two panels of *Le Déjeuner sur l'herbe* (*The Luncheon on the Grass*), pays fraternal homage to his elders Courbet and Manet, whose works hang close by.

Then, on the second floor of the museum, comes a time of maturity and growing individuality,

with room after room hung with the painters' masterpieces. As their styles change and blossom and the subjects diversify or become more concentrated, we can see why Impressionism is fragile in its definition (which cannot be fixed or limited) and strong in its multiform dialogue with man and nature.

As we move through the museum, it is impossible not to spare a thought for the private collectors, who, through their curiosity and generosity, have allowed a French museum to gather together works that the State was so slow to recognise, value and acquire. The first of Degas' paintings to be bought by France were acquired on the sale of the contents of his studio after his death in 1917 but not a single painting by Cézanne has been bought by the State. When the first of Monet's paintings, *La Cathédrale de Rouen. Le portail vu de face; Harmonie brune*, was bought from him in 1907, Count Isaac de Camondo had since 1894 owned four *Cathedrals*, which he fortunately donated to the Louvre in 1911; and it was thanks to the painter Caillebotte's militant clairvoyance that the first Impressionist paintings made their way into the musée du Luxembourg in 1894, shortly after Manet's Olympia had entered the State collections in 1891 at Monet's behest. It was also thanks to a private collector, Dr Gachet, that *Une moderne Olympia* (*A Modern Olympia*), the most criticised painting of the 1874 exhibition, can now be found in the middle of Cézanne's other works.

The Impressionist painters, forced to survive without the help of the State, fortunately managed to attract private patrons, thanks to whom we can now enjoy their works. Despite international recognition, their painting retains something of the individual, private, intimate character of Impressionism which has always been its glory, and which we can make our own in the space of a visit to the musée d'Orsay.

Impressionism

"They have drunk the milk of our age..."

Émile Zola

from 1863 to 1874

■ FRIENDS IN CONVERSATION

■ A BREAK WITH TRADITION

■ A NEW WORLD

■ PORTRAITS

■ OPEN-AIR PAINTING

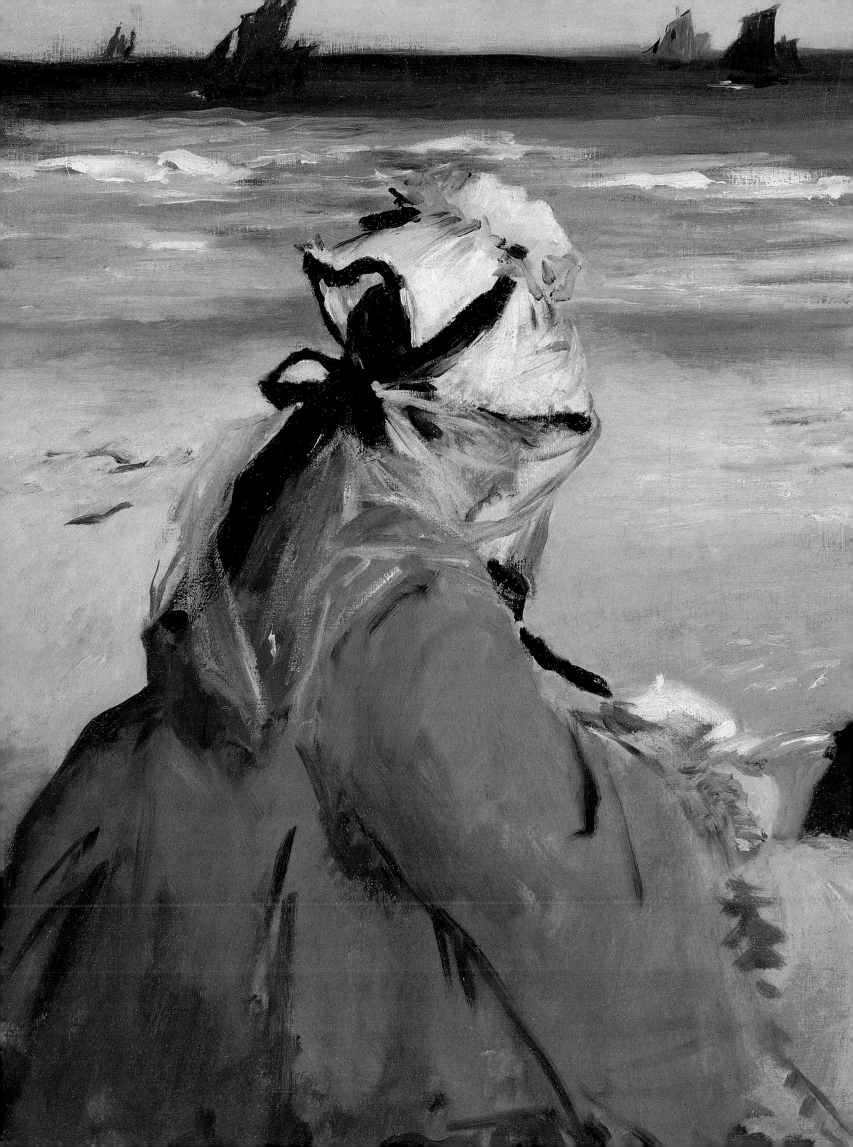

When Degas, Monet, Cézanne, Pissarro, Renoir, Bazille and the others met and became friends in the mid 1860s, they shared the sensation of belonging to a bold new world, which was as pleasing to them as it is frightening to contemporary painters, and which fuelled their conversations at the Café Guerbois. As Monet reminds us in his memoirs, "Nothing could have been more interesting than our discussions, with their constant clash of opinions. We kept each other in suspense, we encouraged each other to make sincere, disinterested experiments and we stocked up enough enthusiasm to last for weeks until an idea finally came to fruition. We always emerged from them stronger and more determined, and thinking more clearly."

"Everything is working, everything is growing, everything is increasing around us…" was Maxime Ducamp's enthusiastic response, as early as 1858, when he saw the divorce that existed between a society that had adopted a luminous modernity and an ossified art which went on reproducing nymphs and shepherds worn out by centuries of devoted service.

The first choice made by the future Impressionists was therefore the modernity of their subjects. Yet Degas would be tempted to become a heroic painter, the saviour of historic painting, which everyone could tell was moribund, while Cézanne would endlessly revisit classical and historical themes. As Duret explains, the paths the Impressionists followed had in part been opened up by their elders: "The Impressionists did not suddenly appear out of nowhere, they did not spring up overnight like mushrooms. They

are the result of the normal evolution of the modern French school." At the very beginning of the 1860s, Manet had taken the path of modernity to the jeers of most of the critics and visitors to the Salon. *Le Déjeuner sur l'herbe* (*The Luncheon on the Grass*), which was exhibited at the Salon des Refusés in 1863, shows both the pictorial tradition's lasting attraction for Manet – it was inspired by Titian's *Concert champêtre* and an engraving by Raimondi – and the difficulty of developing a new language. *Olympia*, on the other hand, which was painted the same year, is an unambiguous statement of its author's modernity, with its deliberately spare drawing, flat composition and almost garish colours. Manet made his immodest prostitute the mother of a new school, one so modern that it disconcerted even Baudelaire, the poet who had longed for her since 1845; so modern that the terms realism and naturalism suddenly seemed hackneyed. Manet became the leader of a new school.

But the subject, however modern, is not enough to make a modern painter. Many skilful artists have tried to combine smooth, careful, highly-polished execution with everyday subjects without ever reforming an art worn out by years of academic teaching or, as Zola put it, "by centuries of lies". And, in fact, the other choice the Impressionists made was to boycott the teaching of the Académie des Beaux-Arts, the only recognised art school since its foundation in the 17th century. By the second half of the 19th century, however, the school was on the decline. It no longer had room for all the student artists who wished to attend it, their

number and discontent having grown continuously since the beginning of the century. Above all, it was incapable of changing what it taught. The studio of Thomas Couture, a vigorous Second-Empire painter, was where Manet learned to paint, and not the École des Beaux-Arts. Renoir and Degas attended the school for a while but both left before reaching the once prestigious and much sought-after Prix de Rome. Monet, Cézanne, Pissarro, Sisley and Bazille quite simply ignored the official training ground, preferring to study the basics of their profession elsewhere: with the painter Charles Gleyre, not so much because they agreed with his principles but because he respected their independence; at the Académie Suisse, which provided them with a live model; at the Louvre; and out on the road in the open air, where they took the advice of landscape painters such as Corot, Daubigny, Boudin and Jongkind. From these varied sources was born the future Impressionists' non-uniform style of painting made up of lightness, frankness, simplicity and, sometimes, brutality.

In his account of the Salon of 1868, Zola was thus able to note the triumph, in both subject and form, of a new style of painting: "There is no need for me to plead here the cause of modern subjects. That cause has long since been won... We are now, thank heavens, free of the Greeks and Romans... All we face now is reality, in spite of ourselves we still encourage our painters to reproduce us on their canvases as we are, with our costumes and customs... Painters who love their times with all their artistic hearts and minds see reality differently... they interpret their era like men who feel it stirring within them, who are possessed by it and are happy to be possessed by it... Their works are full of life because they have taken them from life and painted them with all their love of modern subjects."

This was the irresistible force with which the future Impressionists would confront and upset all the traditions of painting. They took the genres encoded by the Academy in the 17th century one by one and looked at them anew, like Courbet before them, preferring the everyday heroes of their own times to those of antiquity. But, watching the moves of their contemporaries, they endlessly corrupted the definitions of the genres, responding to each other and outdoing one another in boldness. This is true of Manet's *Déjeuner sur l'herbe* (*The Luncheon on the Grass*), which reminds us of the royal repasts painted in the early 18th century (and which Courbet had already perverted by painting feasting hunters life-size). Manet retained the scale of the paintings and the luncheon theme and added the entirely contemporary theme of the gathering of city people with the completely incongruous theme of the nude. In 1866, three years after Manet, Monet returned to the theme, replacing nudity with the elegant clothes of his young models and, above all, transposed the scene to a clearing in the forest of Fontainebleau, painted from life, which envelops the contemporary gathering in a vibrant play of colours. To underline his sources, Monet playfully painted a dashing, youthful portrait of his old friend Courbet in the centre of the picture. It then only remained for Cézanne to provide

his own interpretation of the subject, which he did in about 1870 with his *Pastorale* or *Idylle* (*Pastoral* or *Idyll*). The large figures that Monet introduced into his *Déjeuner* (*The Luncheon*) gave rise to a graceful army of other young men and women and couples let loose in the gardens and fields. Monet's *Femmes au jardin* (*Women in the Garden*), Bazille's *La Robe rose* (*The Pink Dress*) and many others celebrate the union of man with a pleasing, domesticated nature, the union of the portrait with landscape.

Under the brushes of the young artists, the portrait, another classical genre, was also undergoing many changes, mingling in ever-bolder compositions the codes of portraiture, genre painting and historical painting. In 1868, in his portrait *Émile Zola*, Manet drew up a brilliant two-pronged manifesto: he painted the man of letters who had courageously and passionately come to his defence, and, through the accessories chosen by the critics – brochures, an engraving and a Japanese print – defended his own pictorial credo. It was in 1868 also that Monet painted a triumphant dress for the model of his portrait *Madame Louis-Joachim Gaudibert*, showing her face in profile, something which ran counter to the very idea of a portrait. Degas, for his part, used the strict, classical rules of portraiture as applied by the Florentine masters and Ingres to display the impenetrable mysteries of family life in his large-scale portrait *La Famille Bellelli* (*The Bellelli Family*); and Cézanne, in his portrait *Achille Emperaire*, raised his thin, misshapen friend to the rank of emperor. But it was, of course, in landscape painting that the Impressionists made the most varied and most sweeping changes. Zola reminds us that "the classical landscape is dead, killed off by life and truth. No one would dare to say nowadays that nature needs to be idealised, that the sky and water are vulgar and that it is necessary to smooth out the horizon if you want to paint a beautiful picture." Monet was the instigator of this assassination and rebirth. Zola wrote again about the young painter: "He has drunk the milk of our age, he has grown up and will continue to grow, adoring that which surrounds him... In the fields, Claude Monet will prefer an English park to a forest glade. He likes to find the trace of man everywhere... Like the true Parisian he is, he takes Paris to the countryside and cannot paint a landscape without adding smartly-dressed ladies and gentlemen. Nature seems to lose all interest for him when it does not bear the stamp of our customs." And from the forest of Fontainebleau to the Normandy coast, Monet reinvented the realist landscape of the painters of the Barbizon school, Boudin, Jongkind and Courbet. This renewal had to involve the triumph of open-air painting. Monet was not the only one to indulge in long sessions in the country: Cézanne, Renoir, Sisley, Bazille and Pissarro, again according to Zola, "leave at dawn with their boxes on their backs, as happy as hunters who enjoy the open air." The open-air revolution combined with two other major influences that changed the artists' gaze, that of photography – and Gustave Le Gray's in particular – which formulated the "theory of sacrifice", according to which detail is "sacrificed" to the general effect; and

that of Japanese prints, which also tended to the simplification and exaggeration of light and colour. In 1868, then, as brilliantly witnessed by Zola, everything was in place for the official birth of Impressionism. Monet and Renoir were together preparing to paint the *Bains de la Grenouillère* (*Bathing at La Grenouillère*), where, in the ultimate fusion of the human figure with nature and of the modern subject with the landscape, they were to experiment with more fragmented brushstrokes better suited to recording the vibrations of an instant. The revolutionary search for a greater permeability to light of figures and objects led them for a while to abandon the vast canvases of their beginnings. It was a search fundamental to the genesis of Impressionism, which now broke completely with the legacy of the painters of the Barbizon school, Courbet, Jongkind and Boudin. After years of hesitation, Degas had finally abandoned *Sémiramis* for a *Repasseuse* (*Woman Ironing*). He set aside his creatures of another age and classical compositions in favour of others that were just as elaborate but that played on the false spontaneity of his gaze. At the same time, Cézanne was painting the Mont Sainte-Victoire, near Aix-en-Provence, which became a recurring, obsessive theme in his pictures. All that remained, therefore, for this changing group was to make an impact on the public, critics, art lovers and dealers.

It was no easy task. The jury of the Salon, the only place an artist could hope to win recognition, was drowning in the rising tide of submissions, hampered by rules that kept changing and exasperated by the new school's audacity. More often than not it refused to allow Manet and his young colleagues to exhibit their works. Zola denounced the Salon's haphazard way of dealing with Pissarro: "Refused by some Salons and accepted by others, the painter has so far been unable to work out the rules followed by the jury in accepting or rejecting his works... The jury is like a pretty woman: it only takes what it pleases and what pleases it today won't necessarily please it tomorrow." However, other painters had shown a way of remedying this fundamental difficulty, which was to ignore the Salon and exhibit independently. Courbet had done it in 1855 and 1867. Manet had followed suit in 1867. Monet, Pissarro, Bazille, Cézanne and Sisley had attempted a collective exhibition in 1867. Even though they were unsuccessful, they realised that their future lay in pooling their strengths and talents.

FRIENDS IN CONVERSATION ▪ ▪ ▪ ▪

L'Atelier de la rue de la Condamine
(The Studio in the Rue de la Condamine)

1870 ▪ 98 x 128.5 cm

Frédéric **Bazille** 1841 - 1870

In the course of his short career, Bazille painted his studio three times, depicting the artist's life he had always dreamt of. He willingly shared his studios with his less affluent friends from Gleyre's, Renoir and Monet, making them just as much places to socialise and meet people as to work. The painting *L'Atelier de la rue de la Condamine* shows this very clearly.

"So far I've amused myself by painting the inside of my studio with my friends. I am myself being painted in it by Manet," wrote Bazille to his parents on 1st January 1870. Manet and Monet are grouped around the easel talking to the studio's owner. Zola, standing on the stairs, and Renoir, sitting on a table, are talking to each other, while Edmond Maître is playing the piano. It is a small, select group of exponents of the new style of painting and the work is an informal manifesto of emerging Impressionism. The studio is bathed in light and is wide open to the sky and rooftops of Paris, inviting the artists to leave their workshops and paint the life that pulsates outside. There was no head of the school, only painters happy to exchange ideas – refined, elegant artists quite unlike the daubers denounced by newspapers or the members of the juries of the Salon who regularly refused their works. This was the convivial spirit in which Bazille envisaged organising a group exhibition in 1867: "We have therefore resolved to rent a large studio every year in order to exhibit as many of our works as we like."

The members of this small, friendly, respectful group painted many portraits of each other, each artist seeking to pay homage to the talent and personality of the other.

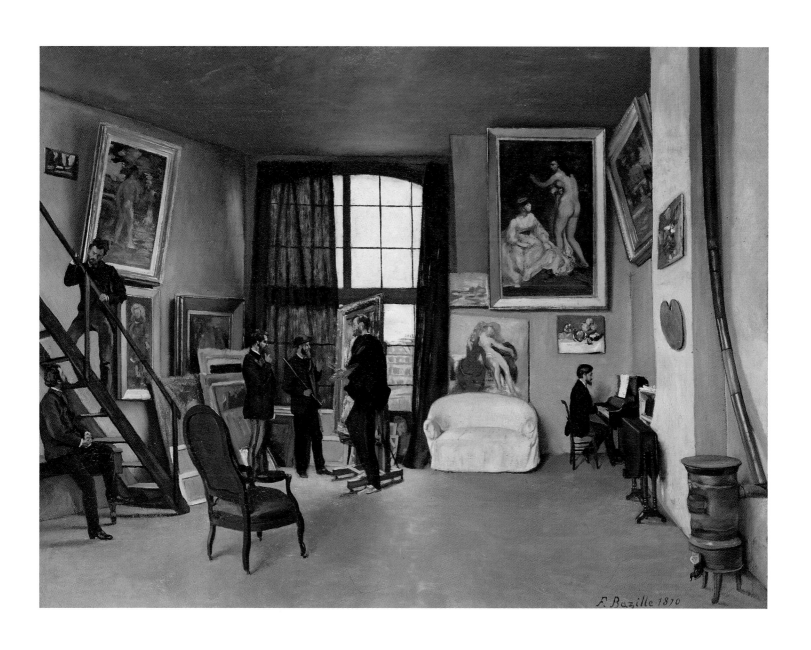

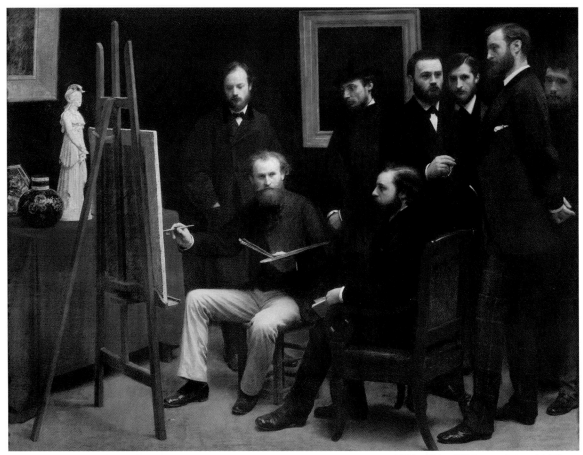

Henri **Fantin-Latour** (1836–1904) ▪ *Un atelier aux Batignolles (A Studio in Batignolles)*, 1870 ▪ 204 × 273.5 cm ▪ Salon of 1870

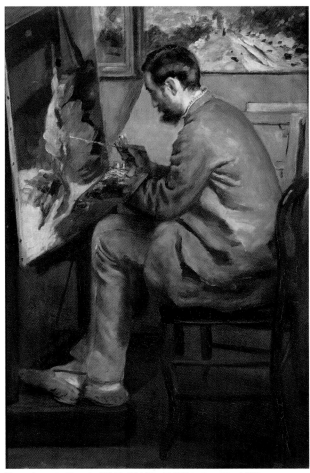

Pierre-Auguste **Renoir** (1841–1919) ▪ *Frédéric Bazille*, 1867 ▪
50 × 73.5 cm ▪ 2ⁿᵈ Impressionist exhibition, 1876

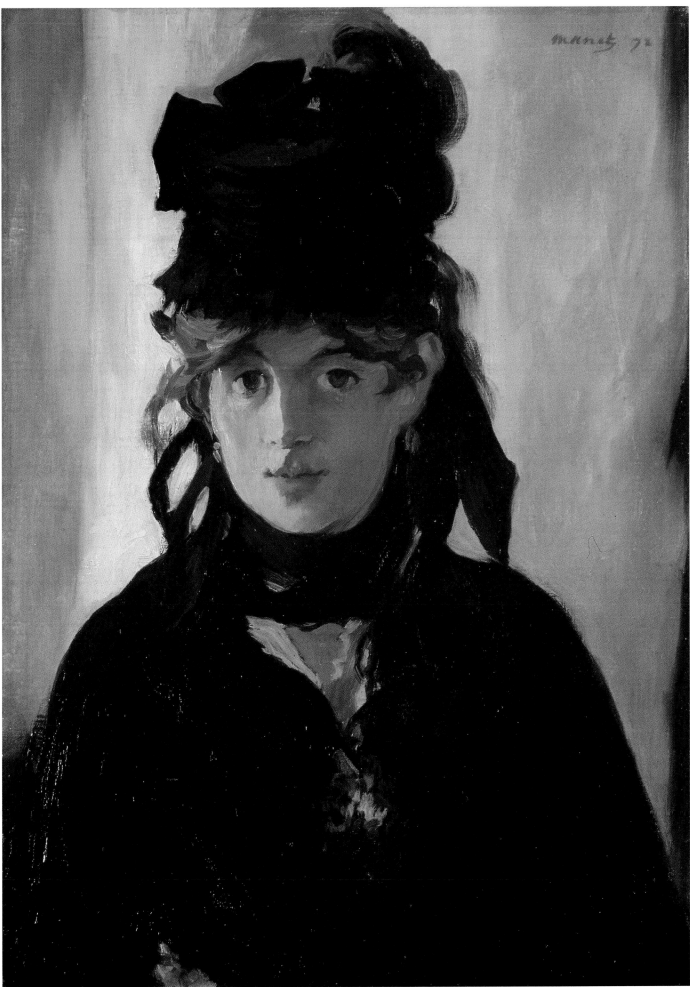

Édouard **Manet** (1832–1883) ▪ *Berthe Morisot au bouquet de violettes (Berthe Morisot with a Bunch of Violets)*, 1872 ▪ 55 × 38 cm

A BREAK WITH TRADITION ▪ ▪ ▪ ▪

Le Déjeuner sur l'herbe
(The Luncheon on the Grass)
1863 ▪ 208 x 264.5 cm ▪ Salon des Refusés, 1863

Édouard **Manet** 1832 - 1883

This painting was probably the most decried of all the works shown at the Salon des Refusés in 1863. This exhibition was staged alongside the official Salon to show works refused by the jury, which had been particularly severe that year, so that the public, which had been regularly alerted to the artists' difficulties, could form an opinion. The work, a complex one, is a bold study in paradoxes that unsettled visitors to the exhibition. The first paradox was the inexplicable presence of a naked woman near two men in city suits. The second paradox is the blend of famous historical references (the *Concert champêtre* [*Country Concert*] by Titian and the *Jugement de Pâris* [*Judgement of Paris*] by Marcantonio Raimondi) and resolutely modern execution. The third paradox is the shocking offhandedness of the naked woman, who makes no gesture of modesty despite the incongruity of her situation. The last paradox lies in the categorisation of the painting, which was originally entitled *Le Bain* (*The Bath*) and which Manet's friends made out to be an open-air work when it had quite obviously been painted in a studio following a practice that the painter would only partly abandon in the late 1870s. While the work does not display all the technical innovations of Impressionism, which were yet to come, it is nevertheless an important milestone in the history of 19th-century art and in the minds of artists: Manet cooly overturned the painting code and accepted refusal by the Salon by imposing the image of a nude in the absence of any mythological pretext and by painting in a straightforward, changing, simplified way. With this masterpiece, Manet became for several years the leader of an informal school that aspired to the complete renewal of painting, and the inspirer of paintings, such as Cézanne's, with obscure, provocative innuendoes.

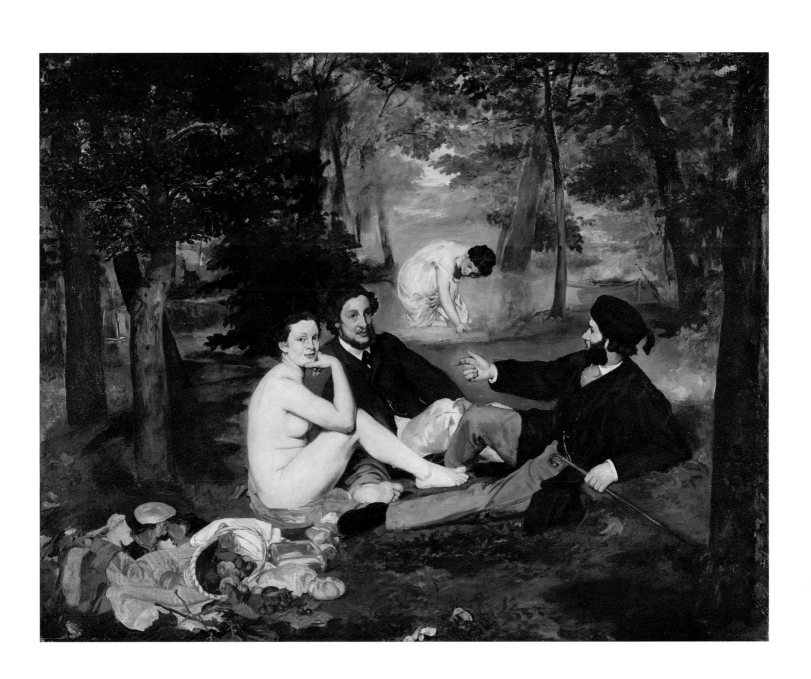

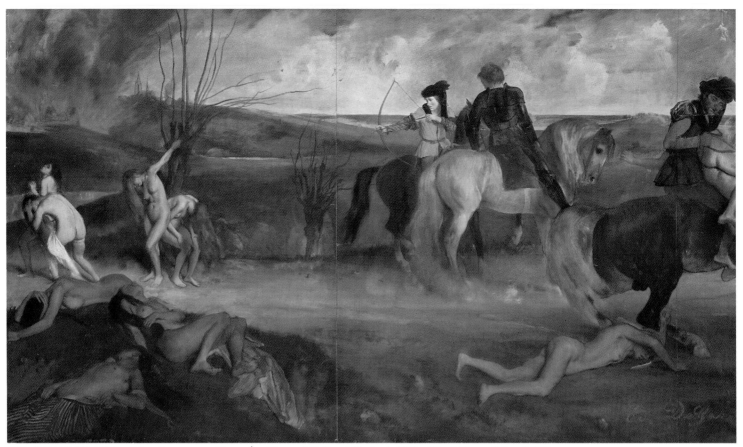

Edgar **Degas** (1834–1917) ▪ *Scène de guerre au Moyen Âge (Scene of Medieval Warfare)*, 1865 ▪ 85 × 147 cm ▪ Salon of 1865

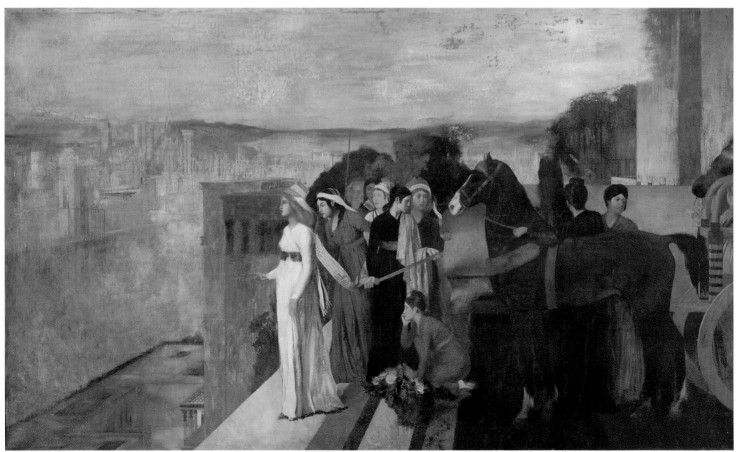

Edgar **Degas** ▪ *Sémiramis construisant Babylone (Semiramis Building Babylon)*, 1861 ▪ 151 × 258 cm

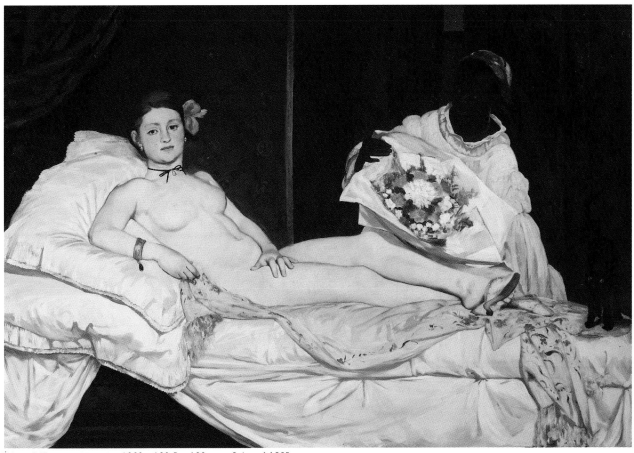

Édouard **Manet** ▪ *Olympia*, 1863 ▪ 130.5 × 190 cm ▪ Salon of 1865

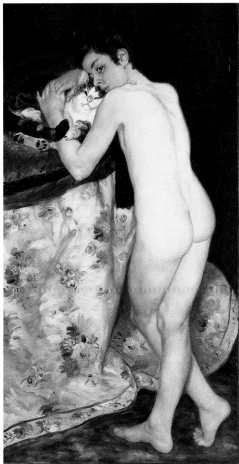

Pierre-Auguste **Renoir** ▪ *Le Jeune garçon au chat,*
(Young Boy with a Cat), 1868–1869 ▪ 124 × 67 cm

Nature morte à la bouilloire
(Still Life with Kettle)
c. 1869 ▪ 64.5 x 81 cm

Paul **Cézanne** 1839 - 1906

Manet had a decisive influence on most of the young Impressionists and especially Cézanne, who admired both the older artist's style of painting and his way of revisiting the traditional subjects of historical painting. This admiration can particularly be seen in the still lifes that Cézanne painted early in his career. Manet had himself painted a large number of still lifes influenced by the Spanish and Flemish painters of the 17th century. In Cézanne's work, we find the same simplicity of composition, the same glossy pictorial richness, the same black outlines around objects as in Manet's. We see in them, too, a profound sense of drama, which grips *La Madeleine* (*Mary Magdalene*), hovers over *Idylle* (*Idyll*), an obscure reworking of Manet's *Déjeuner sur l'herbe* (*The Luncheon on the Grass*), and is evident in the resolute austerity of this collection of objects. The determination to confer a dramatic plastic intensity on the simplest of objects is present in all the still lifes Cézanne painted until the end of his life.

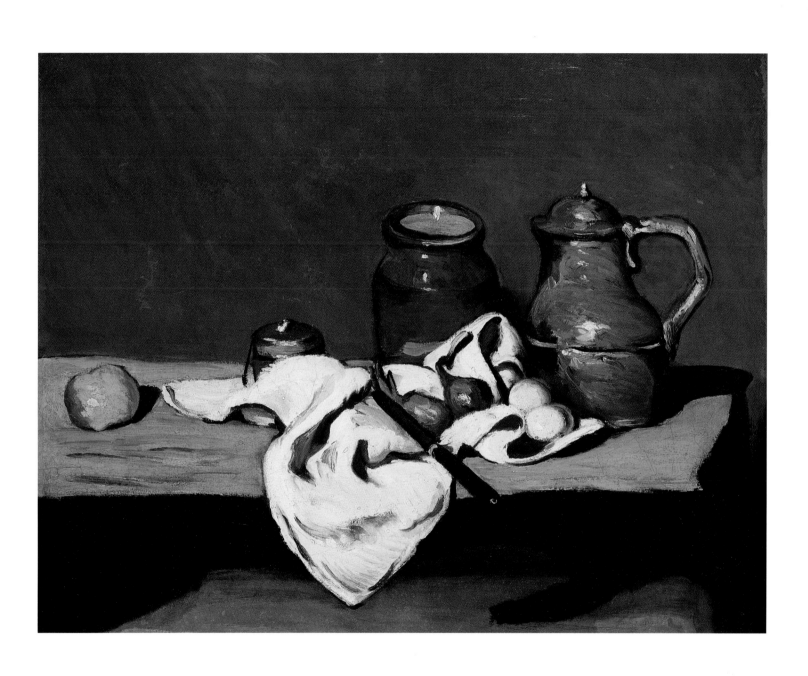

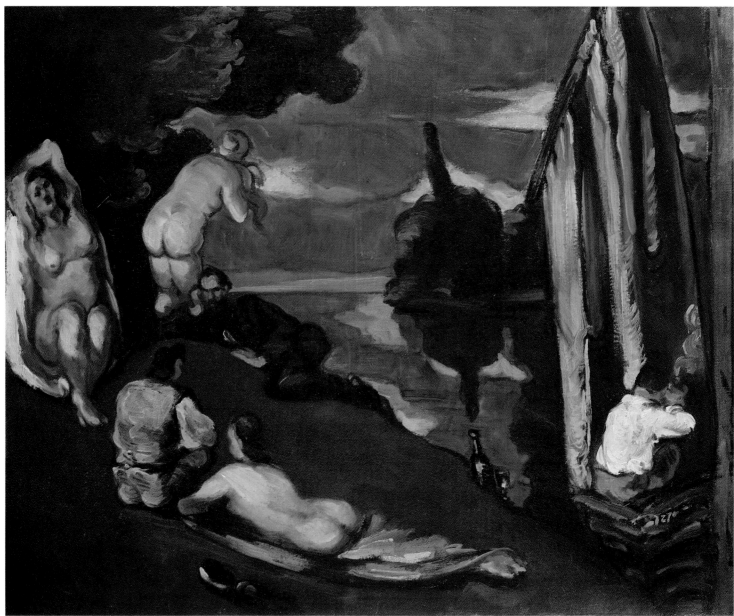

Paul **Cézanne** ▪ *Pastorale* ou *Idylle* (*Pastoral or Idyll*), 1870 ▪ 65 × 81 cm

Paul **Cézanne** ▪ *La Madeleine* ou *La Douleur* (*Mary Magdalene* or *Suffering*), c. 1869 ▪ 165 × 125.5 cm

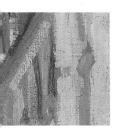

Hôtel des Roches Noires. Trouville
1870 ▪ 81 x 58.5 cm

Claude **Monet** 1840 - 1926

The seaside, which had for several years been given over to the pleasures of the summer visitors was, with its hotels, beaches, beach huts, promenades and sea walls, one of the new subjects that the Impressionists, with their interest in modern life, owed it to themselves to paint. Monet, who was acquainted with the beaches of Normandy, was naturally one of the first to depict its bustle of life, thus echoing the favourite theme of Boudin, with whom he had worked as a young painter. Here, the artist has for once turned his attention slightly away from the sea and concentrated instead on the windy skies and, above all, the brand new architecture of the recently built hotel and the new habits of the smartly dressed summer visitors. Monet's light, bright, sunny palette is well suited to the carefree atmosphere of the scene, which closes his record of the feverish, sumptuous years of the Second Empire. War with Prussia was about to put a brutal end to them and Monet would take refuge in England.

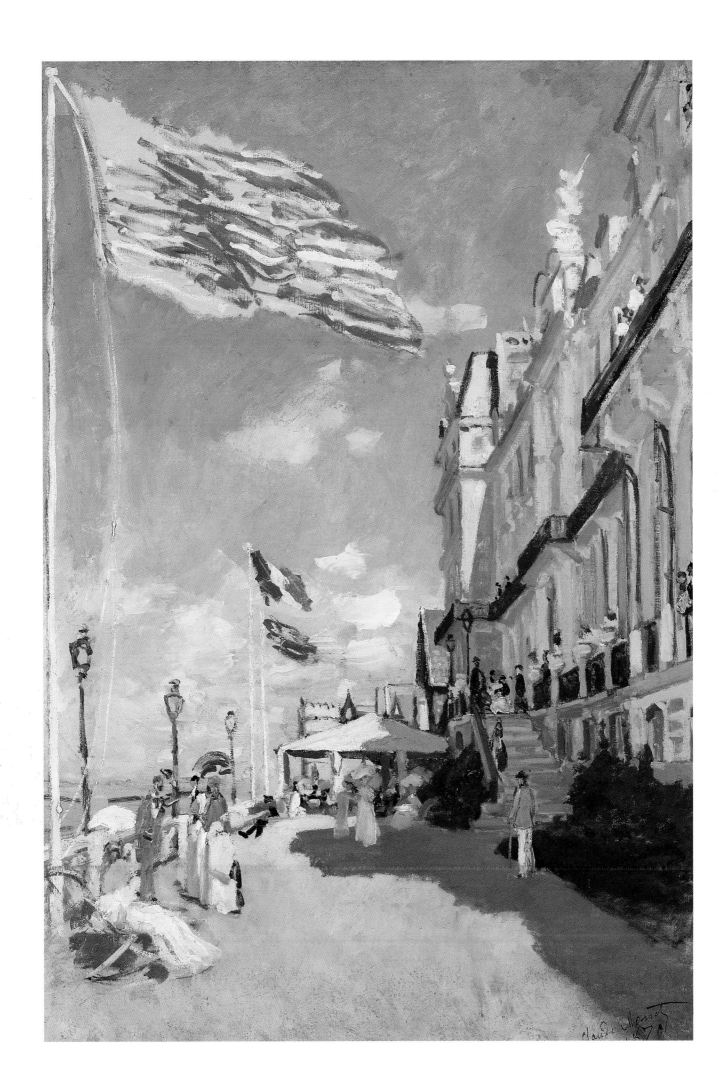

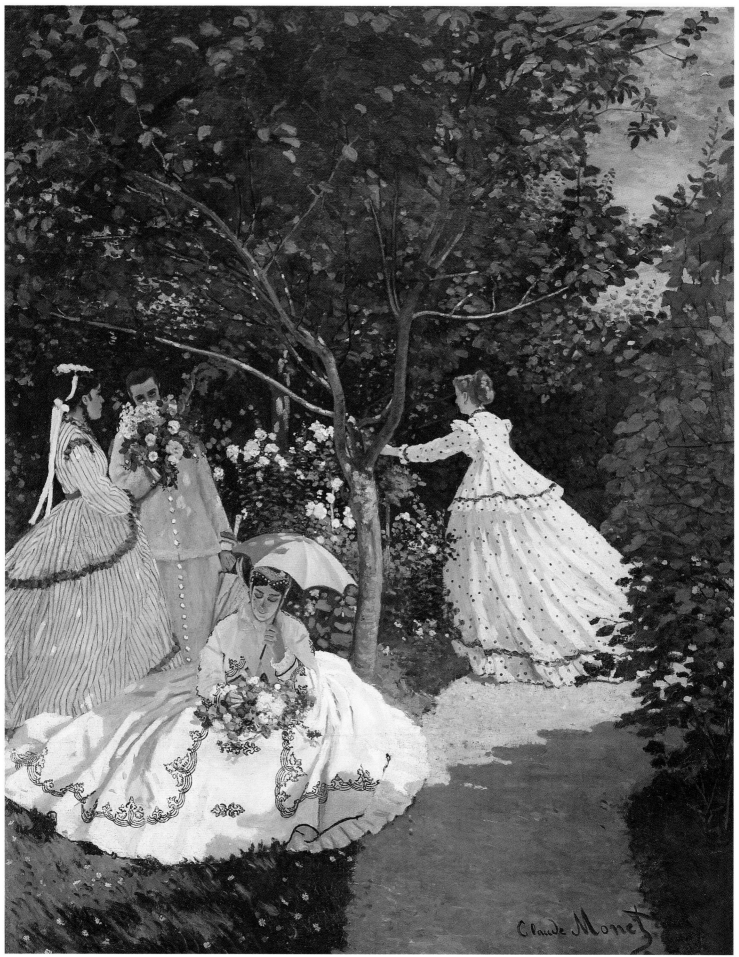

Claude **Monet** ▪ *Femmes au jardin (Women in the Garden)*, 1867 ▪ 255 × 205 cm

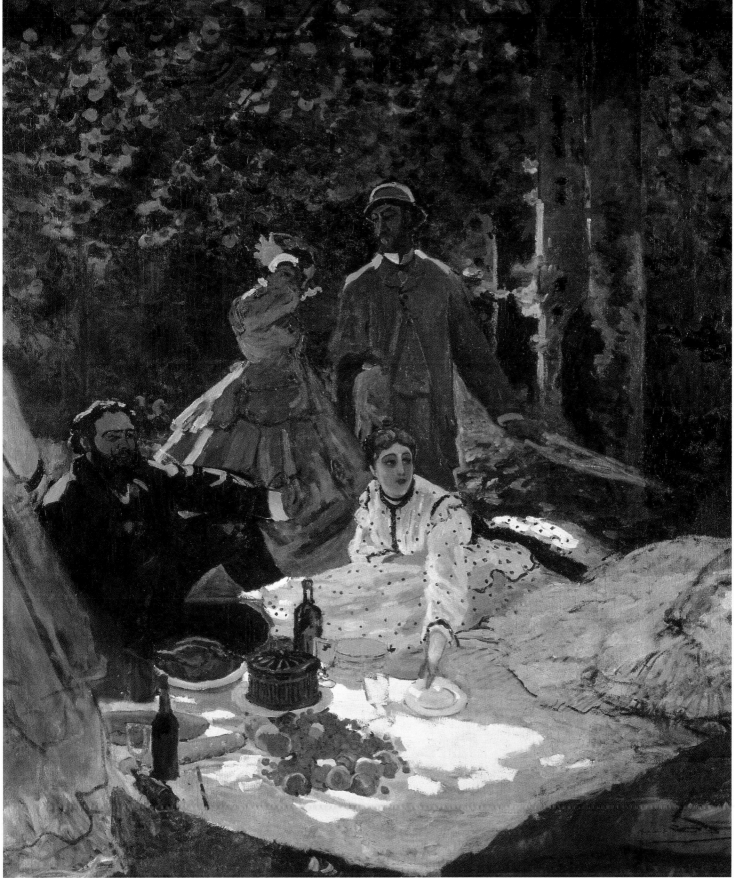

Claude **Monet** ▪ *Le Déjeuner sur l'herbe* (*The Luncheon on the Grass*), fragment, 1865–1866 ▪ 248 × 217 cm

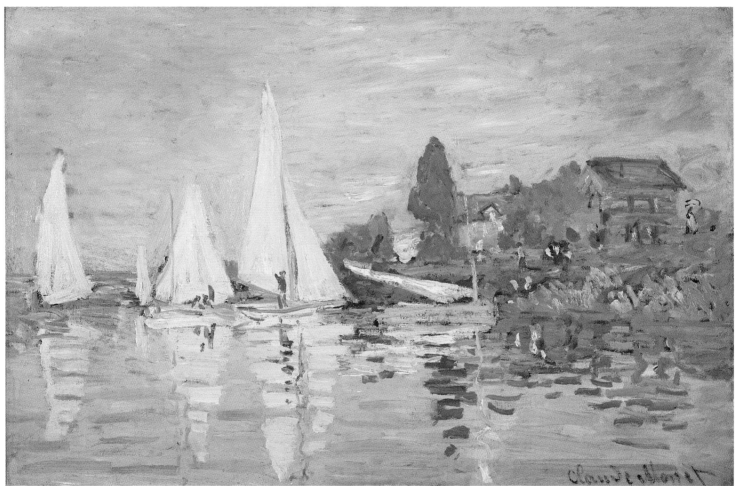

Claude **Monet** ▪ *Régates à Argenteuil (Boating at Argenteuil)*, 1872 ▪ 48 × 75 cm

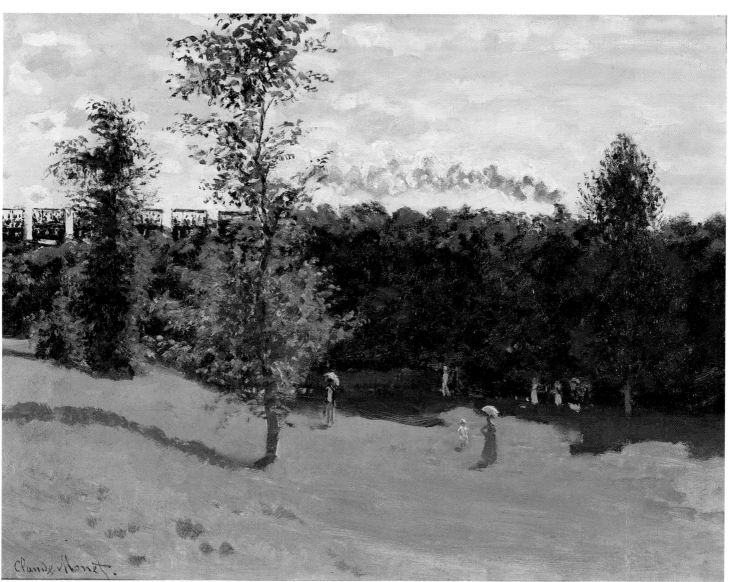

Claude **Monet** ▪ *Train dans la campagne (Train in the Country)*, c. 1870–1871 ▪ 50 × 65 cm

Le Défilé, also known as *Chevaux de course devant les tribunes (Race Horses Before the Grandstand)*
c. 1866–1868 ▪ 46 x 81 cm

Edgar **Degas** 1834 - 1917

In 1845, Baudelaire, who was both a poet and an art critic, had suggested to the painters that they portray the heroes of modern times in their black suits. This idea, passed on by Manet, was adopted by the future Impressionists. In his many portraits, and in scenes such as this, Degas reveals himself to be the poet's worthy successor and the painter of modern life. The racing world, that Manet had already portrayed in 1867, was a creation of the Second Empire, as was that of the seaside and parks. It was a fashionable place attracting the new society that Zola was to describe in his famous novel *Nana*. Degas faithfully renders the topography and atmosphere of the races. He shows the wooden and metal stands with their elegant strolling women, the rails, the racetrack, and the distant chimneys that are reminders of the capital's growing industrialisation. He also shows himself sensitive to the sunny atmosphere of the scene, something that was to become rarer and rarer in later years. He also depicts the horses and their riders, who appear as heroes from the depths of time carrying on the hunting and fighting tradition. Before devoting himself entirely to horses, Degas painted dramatic compositions in which the jockeys struggle heroically with their impetuous mounts.

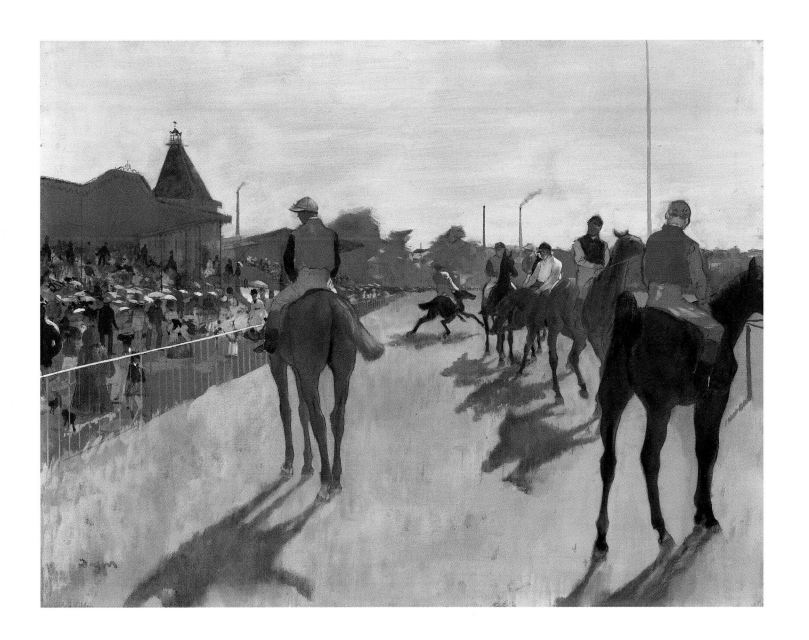

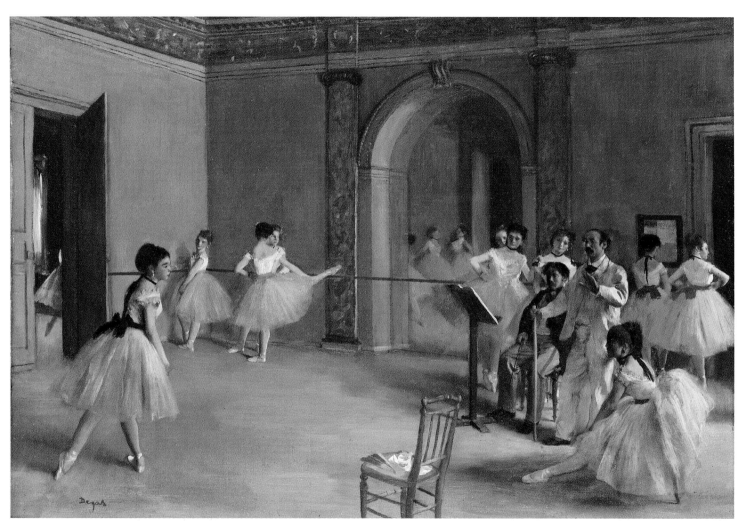

Edgar **Degas** ▪ *Le Foyer de la danse à l'Opéra de la rue Le-Peletier (Dance Studio at the Opera)*, 1872 ▪ 32 × 46 cm

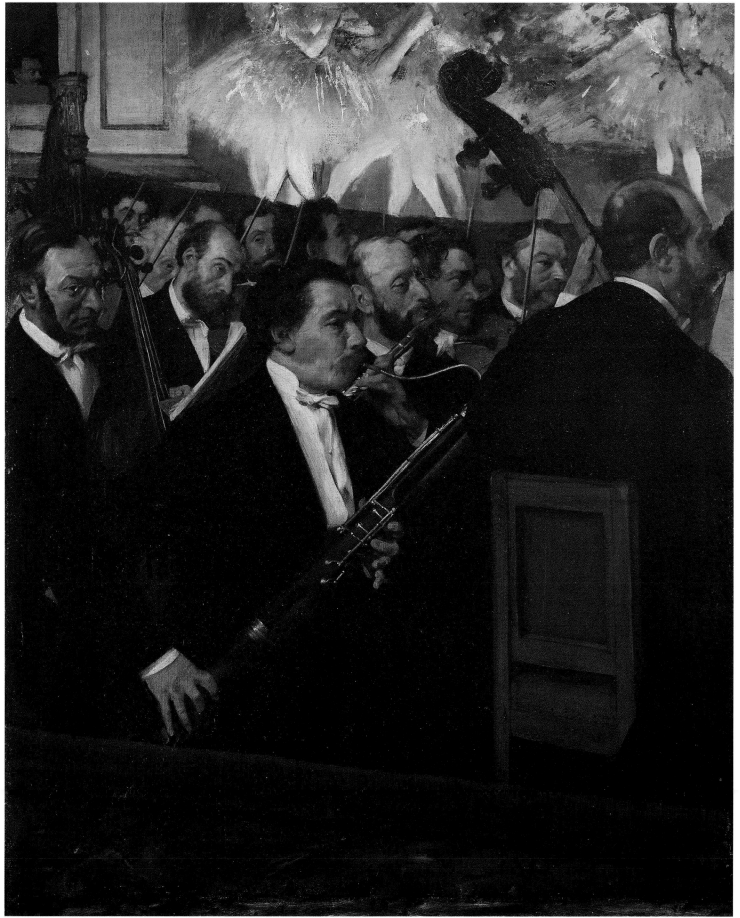

Edgar **Degas** ▪ *L'Orchestre de l'Opéra* (*The Orchestra of the Opéra*), c. 1870 ▪ 56.5 × 46 cm

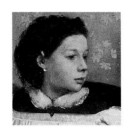

La Famille Bellelli (The Bellelli Family)
1858–1867 ▪ 200 x 250 cm ▪ Salon of 1867

Edgar **Degas** 1834 - 1917

This painting, which was bought by the French State on the death of Degas, is undoubtedly the most famous of his youthful works. Huge and sufficiently ambitious for the painter to have exhibited it at the 1867 Salon, it reveals a pictorial culture full of classical references that the artist, still in his formative years, was pleased to cite. He had in fact started work on the portrait while staying in Florence with his aunt Bellelli after studiously visiting the museums and churches and all the art collections of Italy, where part of his family lived. He also admired Holbein, van Dyck and Ingres, three masters of portraiture. Degas never neglected the genre, which could bring him valuable commissions, having been encouraged in this by his father when he first started painting. Portrait painting also allowed him to carry out an in-depth analysis of the personality and character of his contemporaries in complete confidence. His work therefore includes many portraits and, as with all the future impressionists, these often tend to become much more than the simple image of a face. The portrait of Désiré Dihau ended up as a painting of all the musicians of *L'Orchestre de l'Opéra* (*The Orchestra of the Opéra*), the portrait of Ernest May became a scene at the Paris Stock Exchange. That of *La Famille Bellelli*, with its monumental size and highly structured composition, dramatised the couple's obvious disunity and the daily strife of a family at odds with itself, a situation confirmed by private correspondence and witnessed over a period of months by the painter himself. This demonstrates the "taste for domestic drama, a tendency to discover hidden bitterness between people..." that was the strength and distinguishing feature of Degas' talent.

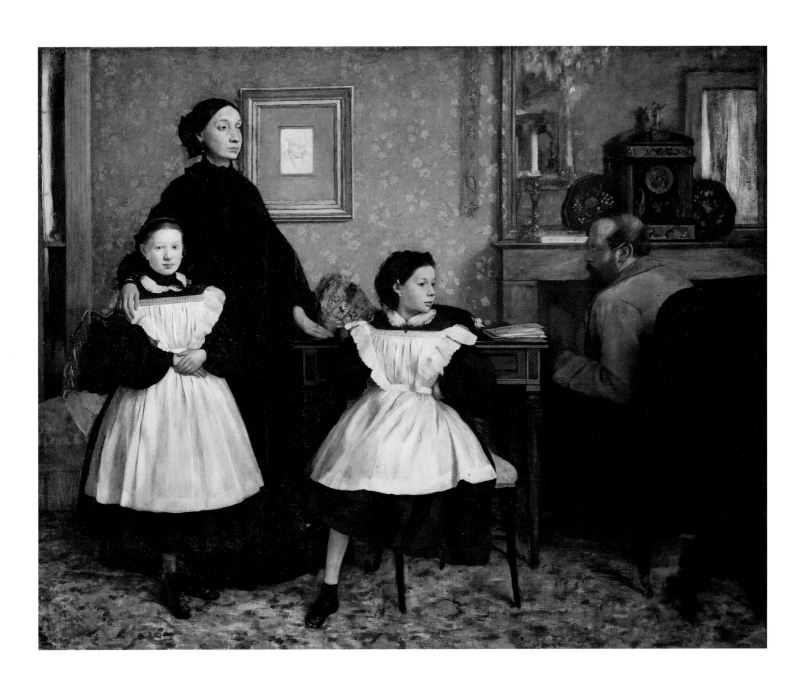

Frédéric **Bazille** ▪ *La Robe rose* ou *Vue de Castelnau-le-Lez* (*The Pink Dress* or *View of Castelnau-le-Lez*), 1864 ▪ 147 × 110 cm

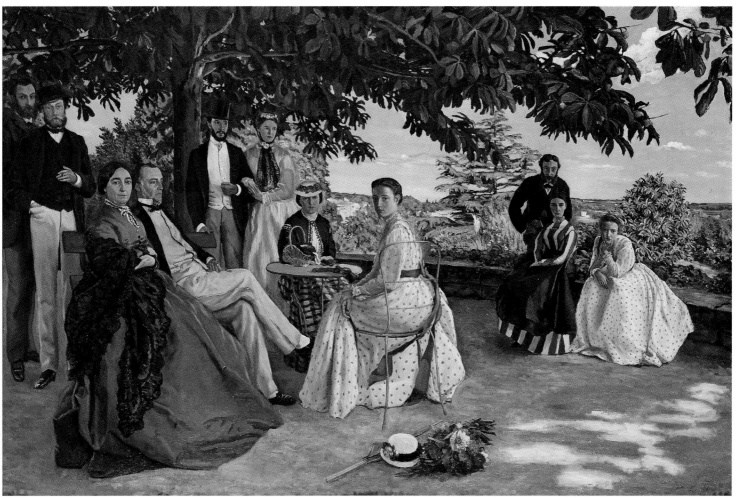

Frédéric **Bazille** ▪ *Réunion de famille (Family Reunion)*, 1867 ▪ 152 × 230 cm ▪ Salon of 1868

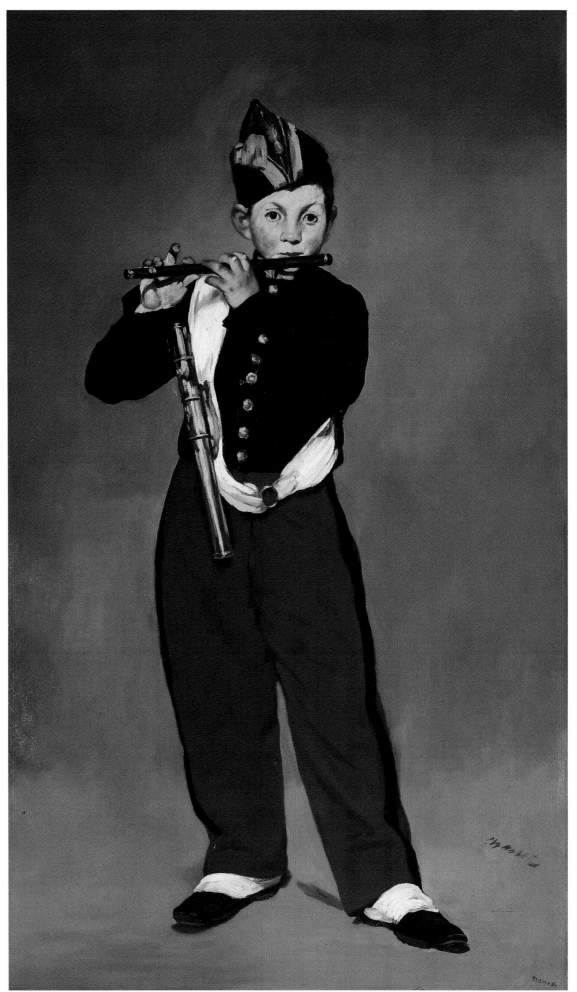

Édouard **Manet** ▪ *Le Fifre* (*The Fife Player*), 1866 ▪ 161 × 97 cm ▪ Manet exhibition, Pont de l'Alma, 1867

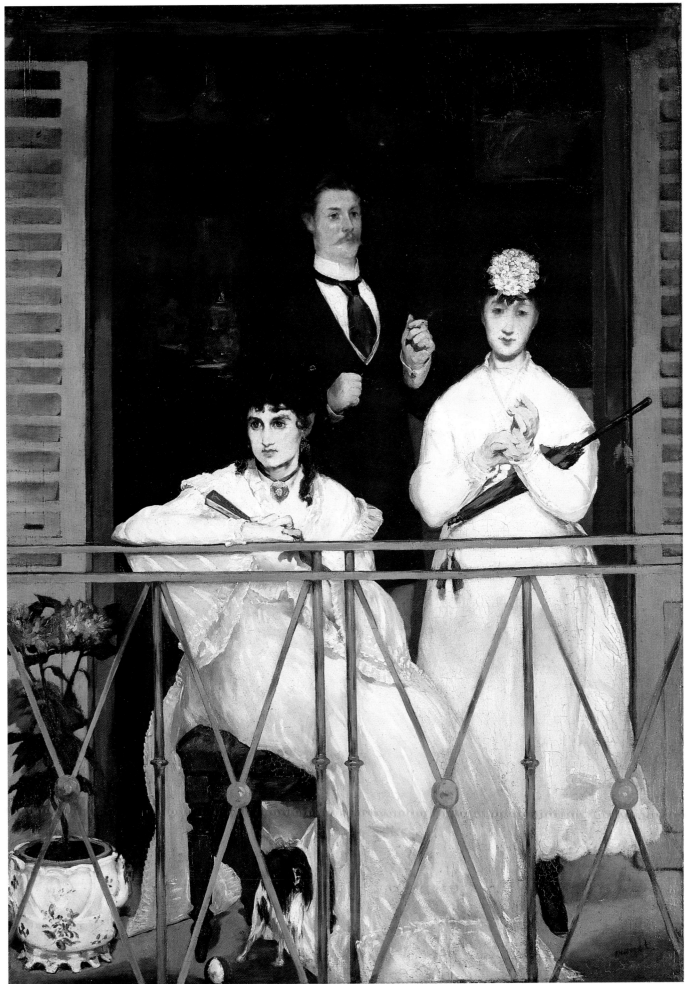

Édouard **Manet** ▪ *Le Balcon (The Balcony)*, 1868–1869 ▪ 170 × 124.5 cm ▪ Salon of 1869

Émile Zola
1867–1868 ▪ 146.5 x 114 cm ▪ Salon of 1868

Édouard **Manet** 1832 - 1883

In 1866, the young writer Émile Zola came to Manet's defence when he wrote with vehemence: "M. Manet's place is in the Louvre, as is that of Courbet or any other artist of a strong, uncompromising disposition." Two years later, Manet thanked him publicly by painting this portrait, which was exhibited at the Salon of 1868. In this work, which is on an ambitious scale, Manet makes plain the new, necessary and unavoidable alliance between the painter and art critic, without whose help the artist can no longer be recognised. Zola is painted with all the traditional trappings of a writer – pen, pen-tray, books and pipe. The pictures above his desk form a mirror in which Manet's shadow seems to be reflected. These include a photo of *Olympia*, his boldest and most accomplished masterpiece, an engraving of a work by Velázquez, whom he admired, a print of a sumo wrestler which confirms the painter's liking for both Japanese art and monumental figure paintings, and, lastly, the blue-covered brochure written by Zola and sold at Manet's exhibition in 1867 that sealed the two men's common struggle. Manet thus realised a virtuoso "portrait of the artist" worthy of the formula invented by the 17th-century academic artists, as well as a lucid stocktaking of the state of painting in France in the 1860s. What he in fact invented was the model of the portrait of the art critic that Degas, Cézanne and later Picasso would make their own.

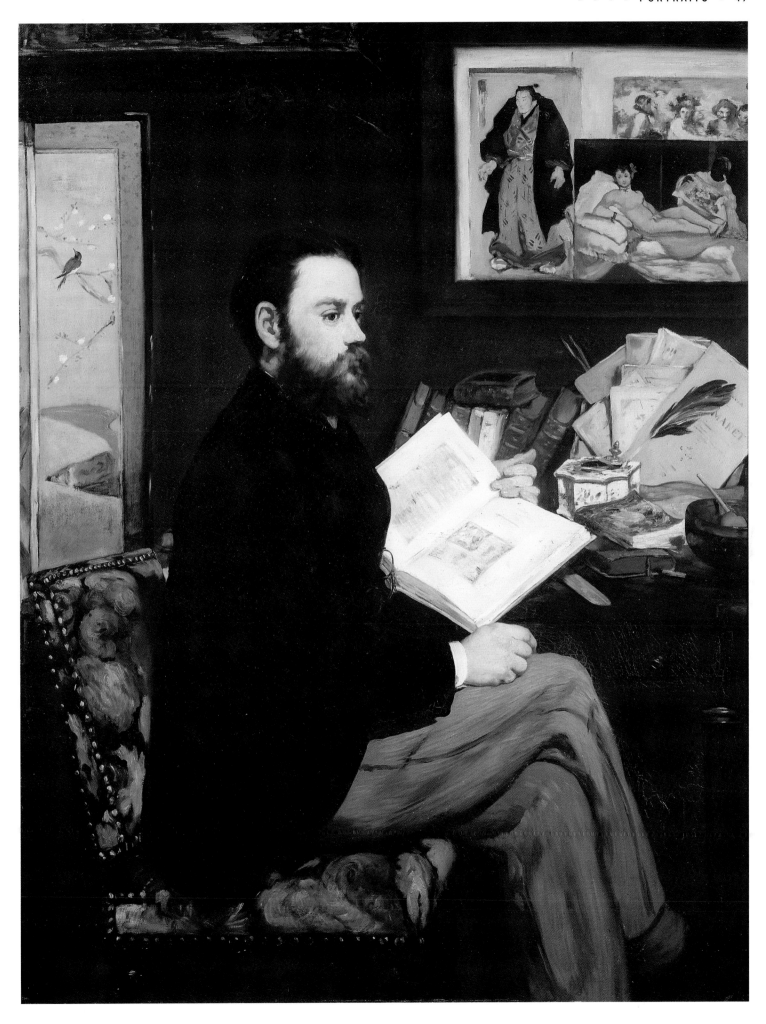

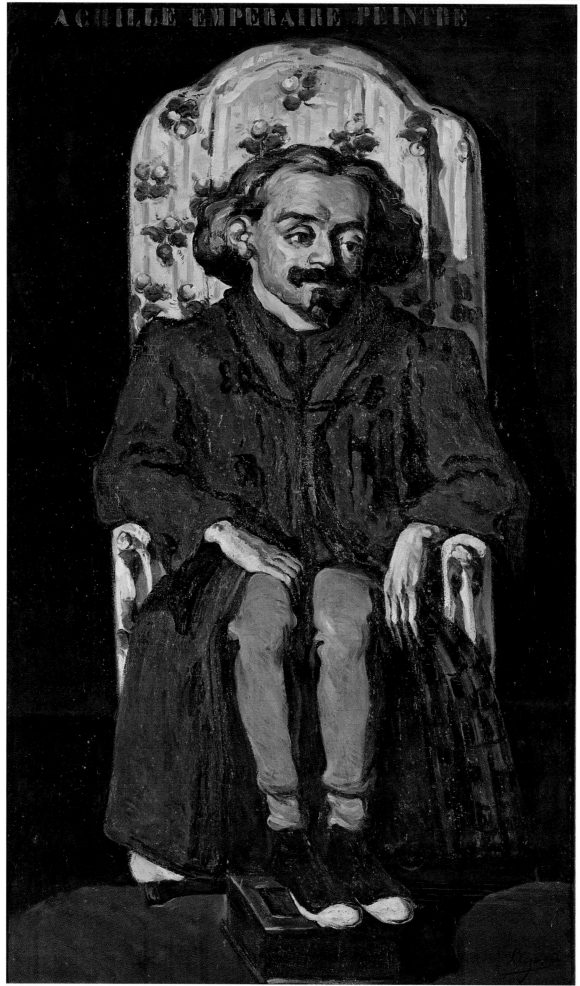

Paul **Cézanne** ▪ *Achille Emperaire*, c 1868 ▪ 200 × 120 cm

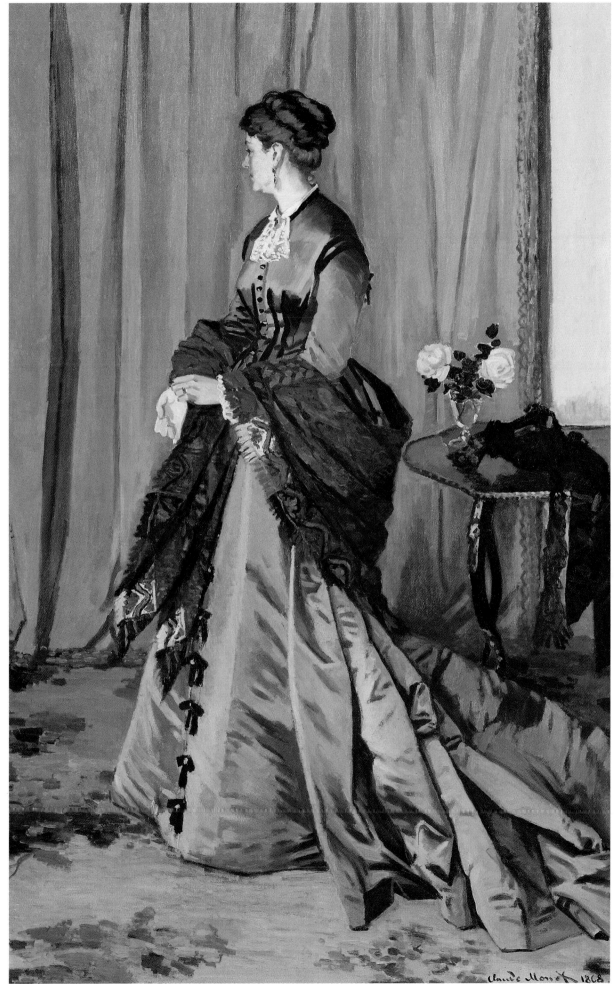

Claude **Monet** ▪ *Madame Louis-Joachim Gaudibert*, 1868 ▪ 217 × 138.5 cm

Variations en violet et vert
(Variations in Purple and Green)

1871 ▪ 61 x 35.5 cm ▪ Londres, Royal Academy Summer Exhibition, 1871

James Abbott **McNeill Whistler** 1834 - 1903

The American Whistler, who was a pupil of Gleyre several years before Monet, Renoir, Bazille and Sisley, was never part of the Impressionist movement. Yet a painting such as *Variations en violet et vert* played a part in the renewal of landscape painting that Monet had been working on since the mid 1860s. This renewal involved the study of the atmospheric changes that Whistler had observed in the company of Courbet on the Normandy coast in 1865 and later in Valparaíso in Chile. The artist, who had the reputation of painting quickly, reconstructed his visual impressions in paintings with titles that include the words "variations" and "harmony" and that translate the atmosphere of the landscapes but also the primacy of the painter's eye over artistic conventions and knowledge. The influence of Japanese prints, from which Whistler took the format, framing and resolutely decorative character of his works, was also decisive. Whistler, who at that time travelled constantly between a London dominated by the cult of the landscapes of Turner and Constable and a Paris shaken by the bold innovations of the open-air painters, achieved a poetic synthesis of these two great landscape traditions. Monet, who took refuge in London from 1870 to 1871, saw Whistler's paintings and offered his reply to the experiments of the American painter, the celebrated *Impression, soleil levant* (*Impression, Sunrise*) that marked the birth of Impressionism.

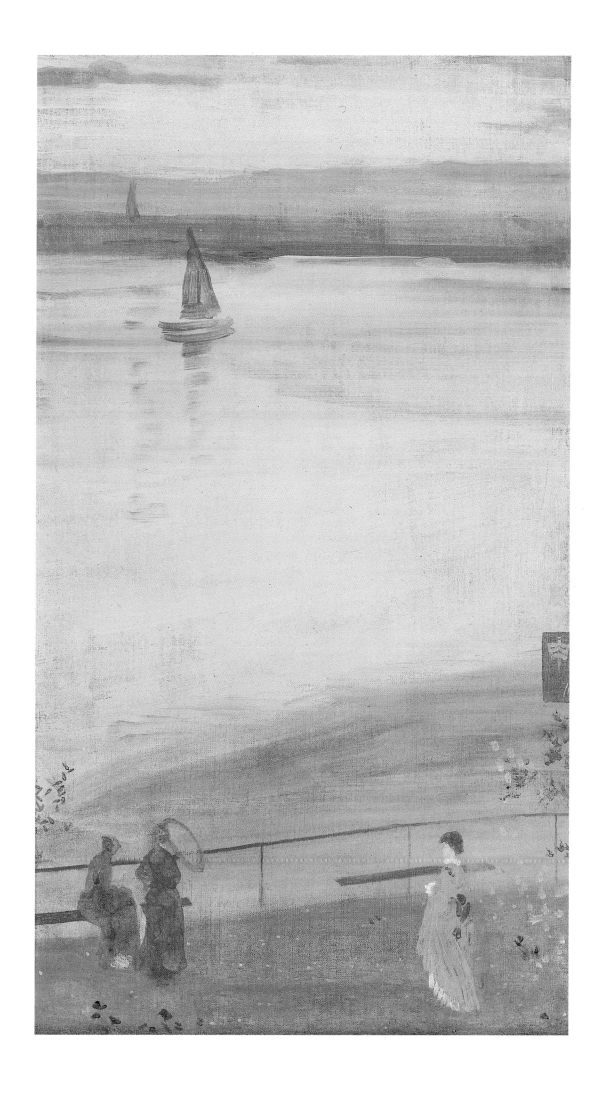

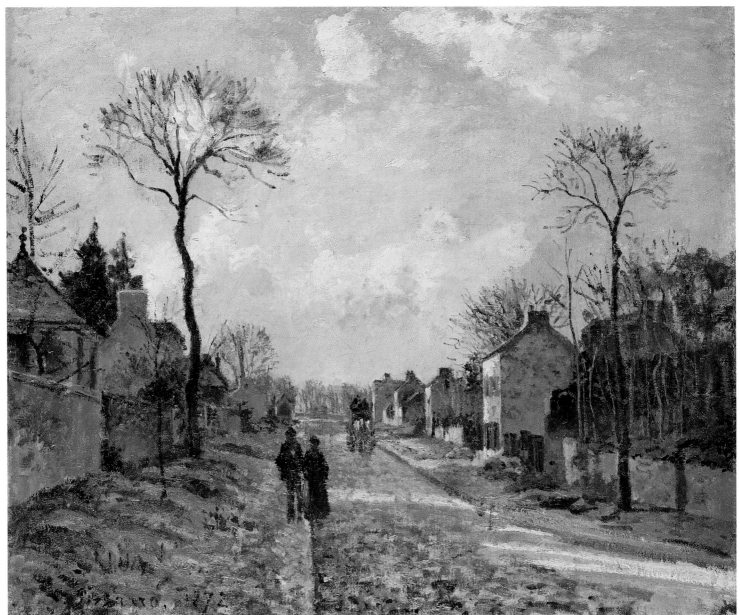

Camille **Pissarro** (1830–1903) ▪ *La Route de Louveciennes* (*The Road to Louveciennes*), 1872 ▪ 60 × 73.5 cm

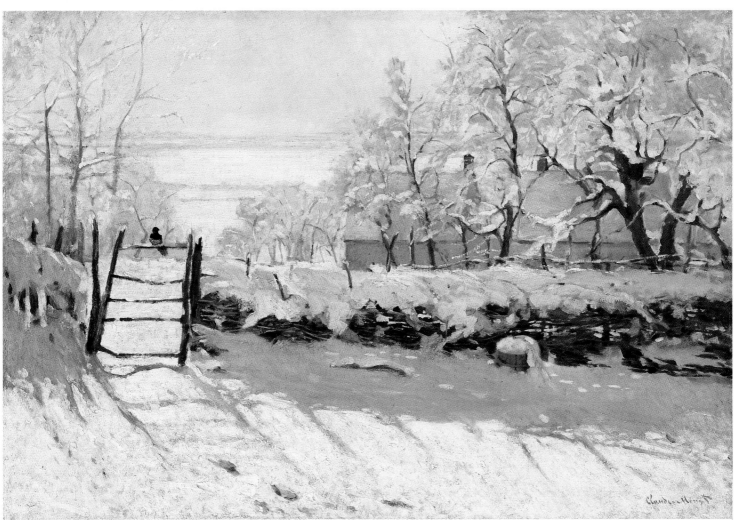

Claude **Monet** ▪ *La Pie* (*The Magpie*), 1868–1869 ▪ 89 × 130 cm

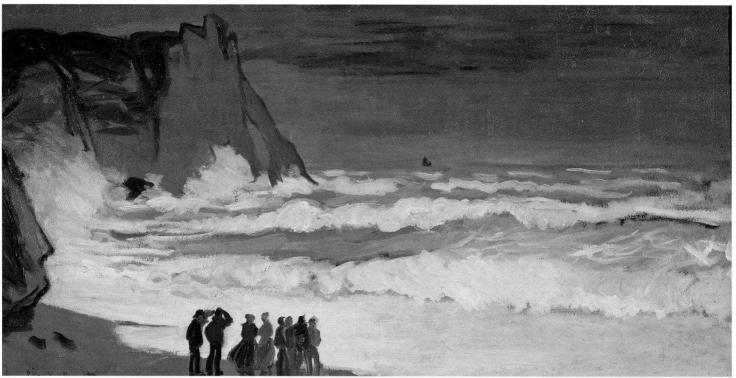

Claude **Monet** ▪ *Grosse mer à Étretat (Rough Seas at Étretat)*, c 1868–1869 ▪ 66 × 131 cm

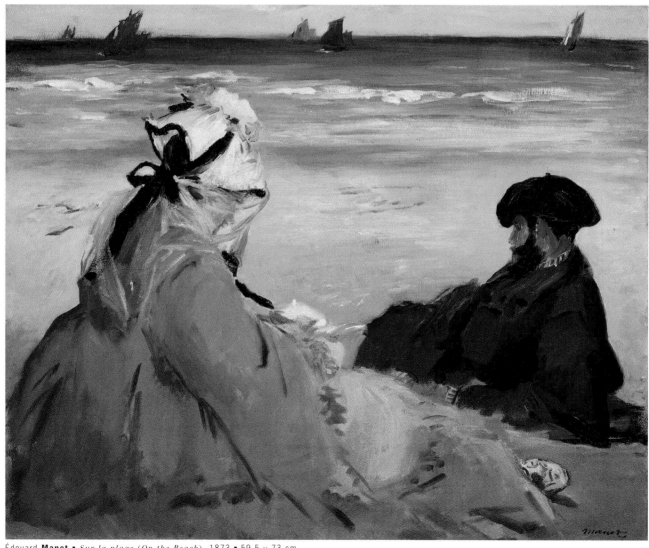

Édouard **Manet** ▪ *Sur la plage (On the Beach)*, 1873 ▪ 59.5 × 73 cm

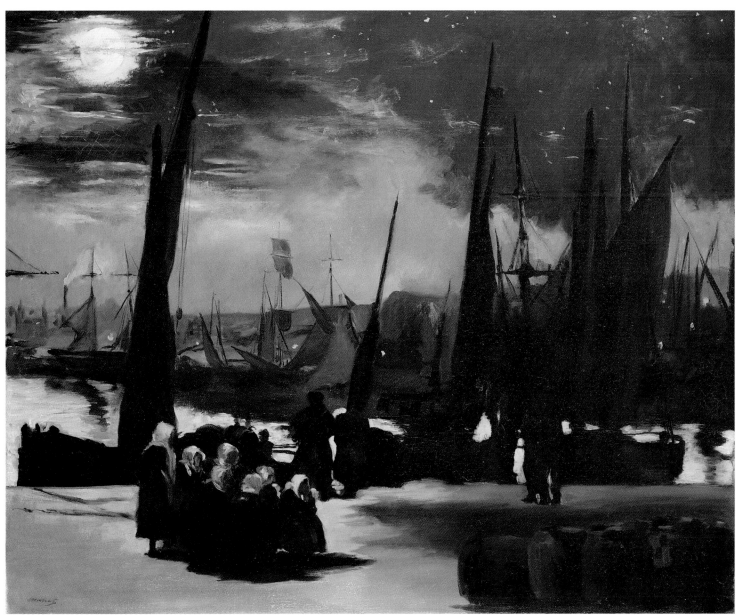

Édouard **Manet** ▪ *Clair de lune sur le port de Boulogne (The Port of Boulogne by Moonlight)*, 1869 ▪ 82 × 101 cm

Impressionism

The twelve glorious years

from 1874 to 1886

- THE PLEASURES OF THE DAY

- REBUILDING THE LANDSCAPE

- MODERN LIFE

- HISTORICAL PAINTING

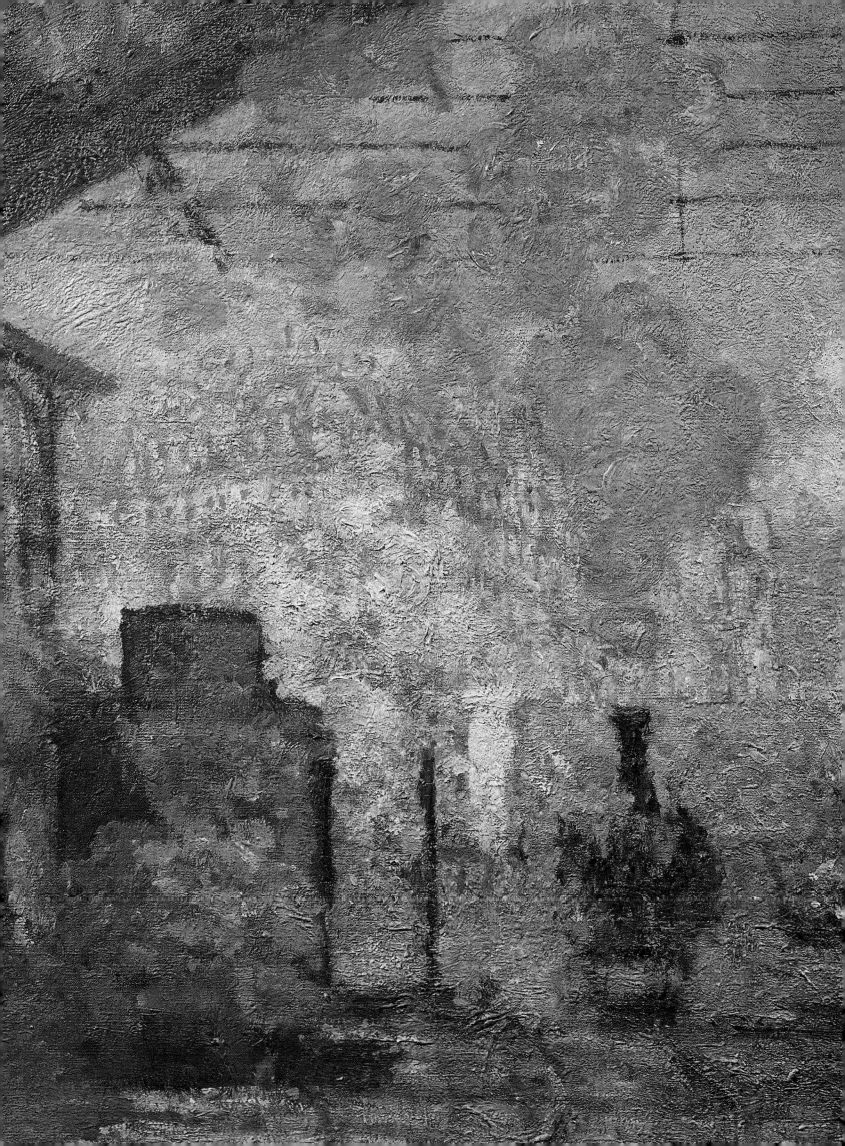

To go from the origins of Impressionism to the height of the movement, you have to climb several floors to the museum's upper gallery, which offers its natural lighting to the painters of light. The distance between the rooms is the tangible expression of the deeper, more fundamental rift created in France by the events of 1870–1871. The Franco-Prussian war, the end of the Empire and the proclamation of the Third Republic, and the Commune and its repression, were all events that shook national, social and private life to the core. "It's all over… we were dying of hunger… you really need to have experienced it to know what it was like," confides Manet, who with Degas took part in the defence of Paris. And even worse than the depression and deprivation was the death of Bazille on the battlefield. Monet, Cézanne, Renoir and Pissarro all fled the fighting and continued to paint. The upheavals in France naturally had repercussions on artistic life at the start of the Third Republic. The creation under the Commune of a short-lived Ministry of Fine Art and Commission of the Arts over which Courbet presided had proved that it was possible for artists to reach agreement. But, like all the initiatives of the Commune, they had a bad press during this period of reconstruction, symbolising disorder and anarchy in the eyes of the country of the "moral order". This explains the often hostile reactions that greeted the first exhibition of the "Company of painters, sculptors, engravers, etc…", on 15th April 1874. Impressionism's founding exhibition had been made necessary by the repeated difficulties experienced by the artists with the jury of the Salon. In 1873, Paul Alexis, a journalist friend of Cézanne's, wrote: "Whatever the case, there is widespread discontent in the art world."

Around Monet and Degas, the active organisers of the exhibition, were gathered Renoir, Cézanne, Sisley, Pissarro and Berthe Morisot, a friend of Manet's. Boudin had answered Monet's call and a few lesser-known artists had come to swell the ranks and share the Company's expenses. Manet, on the other hand, still refused to join his friends. He probably believed that the new style of painting had to be accepted by the Salon, which was attended by some 800,000 visitors each year. Several works that were shown at this historic exhibition are now in the collection of the musée d'Orsay: *Coquelicots* (*Poppies*) by Monet, *Le Berceau* (*The Cradle*) by Morisot, *Une moderne Olympia* (*A Modern Olympia*) and *La Maison du pendu* (*The House of the Hanged Man*) by Cézanne and *Gelée blanche* (*Hoar Frost*) by Pissarro.

The company assembled in 1874 was fairly eclectic. The artists did not have the same motives and some of them soon left the association. Their styles were also different. The signs of a latent break-up were already there but the group nevertheless struggled to gain acceptance. Eight excellent exhibitions were held in the twelve glorious years that followed. By the second exhibition, which took place in 1876, Cézanne was already missing and it took all the strength of persuasion of Caillebotte – the brilliant, new recruit to the group who had made his mark in 1876 with *Les Raboteurs de parquet* (*Planing the Floor*) – to bring together all the great painters of the group for the last time in 1877.

The exhibition of 1877 was also one of the finest and richest of the eight Impressionist shows. If the exhibition of 1874 offered a disparate face, that of 1877 confirmed the individual talents of the artists. The exhibition was placed under the banner of realism but it encompassed two contrasting ways of seeing the contemporary world. On the one hand, there were the landscape painters, who observed the changes in the countryside, the suburbs and the city. They were discovering what the critic Duranty, who devoted a brochure to "the new painting" in 1876, described in the following way: "Through one intuition after another, they have gradually managed to split up sunlight into its rays and elements and then reconstruct it through the overall harmony of the iridescence they spread over their canvases."
Duranty's analyses of the Impressionists' light and colour served Monet only too well so as not to miss the point of the very different work of Cézanne. Fleeing the changing landscapes of the banks of the Seine that delighted Monet, Renoir, Sisley and even Manet, who was now sampling the delights of the open air, Cézanne, sometimes in the company of Pissarro, sought corners of rural countryside in the region of Auvers, Pontoise and Aix-en-Provence that would enable him to satisfy his need for order and structure. He also applied these two requirements to the studies of bathers in which he had now become interested.
On the other hand, there were the painters of modern life led by Degas, whom Duranty defended even more vigorously. He justified the daring framing of Degas, Caillebotte and Manet by what we see when we look out of the window: "Depending on whether we are close to it or a long way away, and on whether we are sitting down or standing up, a window frame surrounds the scenery we can see outside in the most unexpected way, showing us the endless variety and novelty that is one of the saving graces of reality." Unlike Monet and Renoir, who had freed shapes from the prescriptions of drawing – something demonstrated in the extreme by Renoir's *Étude. Torse, effet de soleil* (*Nude in the Sunlight*), which shimmers in the coloured light – these artists never gave up drawing. The short stokes under the colour hold the shapes firmly in place and sometimes, as in the work of Degas and certain parts of Manet's paintings, run over them, overflow them and extend them in a life of their own.
With the group of paintings he devoted to the *Gare Saint-Lazare* exhibited in 1877, Monet proved that, despite the rivalries pulling the group apart, there was only one possible way of seeing, that under which lay the sincerity and vigour of the "temperaments". His *Gares Saint-Lazare* were, in fact, a synthesis of all the aspirations of Impressionism. Showing the hubbub of the station, they embraced the modernity of the century – the movement, the speed and the power. Only humanity appears to be missing from this world of machines: the milling, swaying humanity of Renoir's *Bal au Moulin de la Galette* (*Dancing at the Moulin de la Galette*), the cold, frightened humanity of Caillebotte's large urban compositions and the haggard, cynical or credulous humanity that Degas examined in his paintings and prints. *L'Absinthe* (*Absinth*),

shown at the 1876 exhibition, had revealed the full extent of Degas' ability as an often cruel and pessimistic observer.

The exhibitions thus succeeded one another somewhat chaotically, and the masterpieces also, the Impressionists were still decried and their recognition still delayed. Yet they were supported by shrewd and faithful critics and generous art lovers. Monet, who had been particularly unfortunate, expressed his deep discouragement in 1879: "I am totally disgusted and demoralised by the life I have been living for so long. If it means ending up like this at my age, it's hopeless – unhappy you are and unhappy you will remain… That's why I'm giving up the struggle and the hope." The Impressionists were all the more bitter that Zola, who had analysed their ambitions so well, accused them, in 1880, of not exploiting their talent to the full: " We can see quite clearly what they want, we know they are right; but we look in vain for the convincing masterpiece to which all will bow. That is why the Impressionists have not yet succeeded in their struggle; they remain inferior to the work they are attempting, they stammer and cannot find the words." Flushed with literary success, Zola could no longer understand the more and more instantaneous style of the Impressionists of the late 1870s. The fugitive images, capturing quick portraits of fleeting moments are what their increasingly confident gaze perceived of the accelerating changes in the fascinating world about them.

Manet's death in 1883 was a blow for all the artists. Cézanne spoke of a catastrophe. And even Degas, his eternal rival,

exclaimed: "He was greater than we thought." But if the painter of *Olympia* was the subject of flattering obituaries and a retrospective in the halls of the bastion of academicism, the École des Beaux-Arts, none of the Impressionists could forget the fact that not a single work by Manet was hanging from the picture rails of the musée du Luxembourg, the antechamber of the Louvre, and that not a single work had been recognised and bought by the State. Impressionism was copied, misused and watered down by those who disapproved of it; academic painters took over the Impressionists's light touch and applied it in a purely superficial way to stiff, conventional compositions that were then acclaimed at the Salon. Degas denounced this in no uncertain terms: "They shoot us but they rifle our pockets."

In 1883, however, there was more a tangible light on the horizon. Durand-Ruel, the Impressionists' tireless dealer, bought their work more regularly and Renoir and Degas began to enjoy a comfortable reputation. Monet had just discovered Giverny. His departure, following that of Cézanne, who had withdrawn to the countryside of his Aix-en-Provence childhood, was a flagrant sign of the group's now unavoidable break-up. They would continue down their own individual paths and meet only rarely.

The eighth and last exhibition of the group, which took place in 1886, set the scene for the end of Impressionism's glorious years. As usual, not all the founding members had answered the call, which this time came from Pissarro. Neither Monet, Renoir, Cézanne, Sisley nor Caillebotte were there, the latter having given

up the struggle after years of wheeling and dealing between the different factions of the group. But Pissarro, Berthe Morisot, Degas and his friend Mary Cassatt were there. Above all, there was the strange and irresistible rise of a new generation, with the presence of Gauguin, Redon, Signac and Seurat. Gauguin's participation was nothing new. He had taken his place among the secessionists in 1880 with austere works that owed much to the lessons of Pissarro, the young artists' tireless mentor. But in 1886, the works of Gauguin, inspired by Cézanne and Degas, took a stranger, harsher turn and showed signs of the artist's forthcoming rejection of Impressionism. Seurat and Signac had been brought in by Pissarro who was newly converted to the theories of scientific Impressionism. A whole room was devoted to their fascinating giant exercises in small dots that broke with the more spontaneous manner of their elders. Seurat's *Un dimanche après-midi à l'Île de la Grande-Jatte* (*A Sunday Afternoon at the Île de la Grande-Jatte)* unleashed the sarcasm that had gradually fallen silent around the Impressionist exhibitions.

Redon's mysterious drawings whisper, discreetly but firmly, the end of a triumphant naturalism and the dawn of a new era, that of Symbolism, which can already be seen in some of Degas' pastels, more lyrical in their colours and composition. It can also be seen in Pissarro's pointillist essays, which distance themselves from reality while trying to give it form. Renoir and Monet were modifying their styles along with their subjects. Monet was soon to enter into a powerful dialogue with nature in the raw, freed of all artifice, by going to work on the rugged coast of Belle-Île-en-Mer. This might seem a sad ending but it in fact breathed new life into the Impressionists, who were fired by fresh interest on the part of the dealers and art lovers. Durand-Ruel, who had just broken into the American market, was no longer the only one to invest in Impressionism. Although the group exhibitions were over, personal exhibitions gradually took their place. And in 1887, Fénéon, Seurat's defender, noted with contradictory irony that: "The best days of Impressionism are past. Visitors to the exhibition used to laugh themselves silly in front of the Impressionist paintings in their white frames. They suggested that the madmen who painted them should be locked away, they took pity on their colour blindness and dismissed them as jokers. Now they look at the paintings, understand them vaguely and, if they laugh, laugh nervously."

Le Berceau (The Cradle)
1872 ▪ 56 x 46 cm ▪ 1st Impressionist exhibition, 1874

Berthe **Morisot** 1841 · 1895

It fell perhaps naturally to a woman, who could only with difficulty have gone about alone and set up her easel in awkward places to paint nature or the modern city, to record the tender image of home and motherhood. It was, of course, Berthe Morisot, the wife of Manet's brother and a discreet, tenacious, kind and respected pillar of the Impressionist group, who painted this sensitive picture, which won over the most recalcitrant critics of the first Impressionist exhibition of 1874 at which it was shown. As one of them wrote, "Nothing could be more true or more tender than the young mother leaning over a cradle in which a pretty sleeping baby can be glimpsed through a pale cloud of muslin." Berthe Morisot paid as much attention to the baby as to the mother and even made their gestures match one another. When she became a mother in her turn, like her sister Edme who was her model here, she painted many portraits of her daughter and many scenes of banal but charming family happiness.

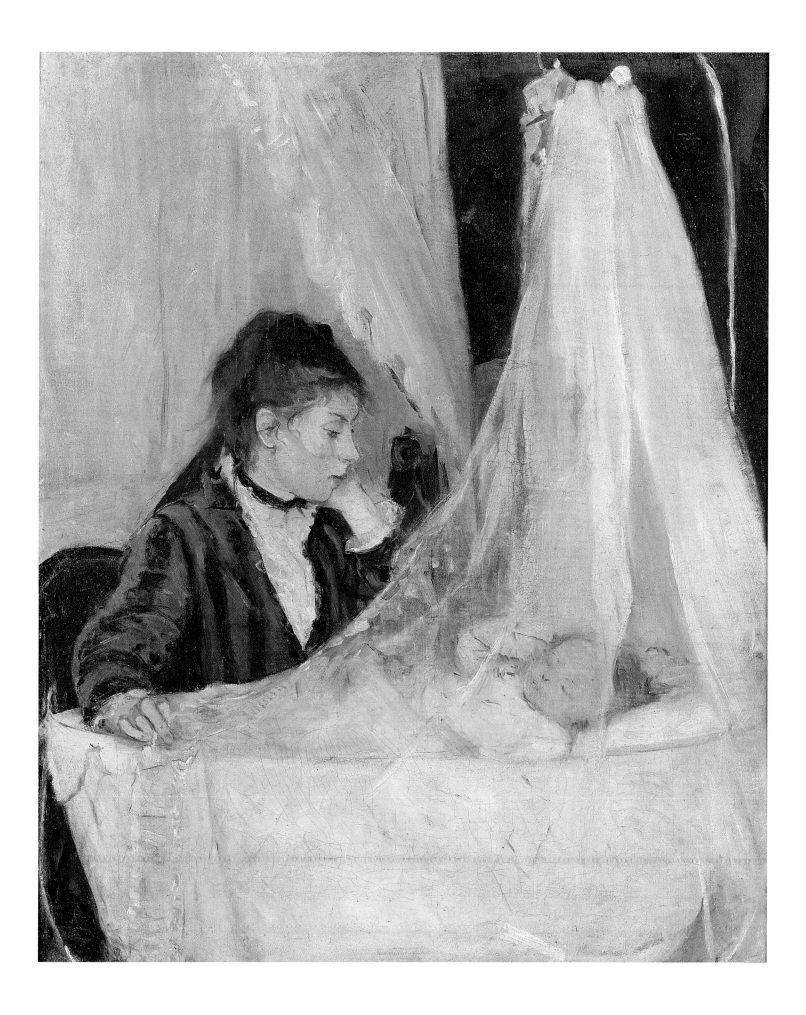

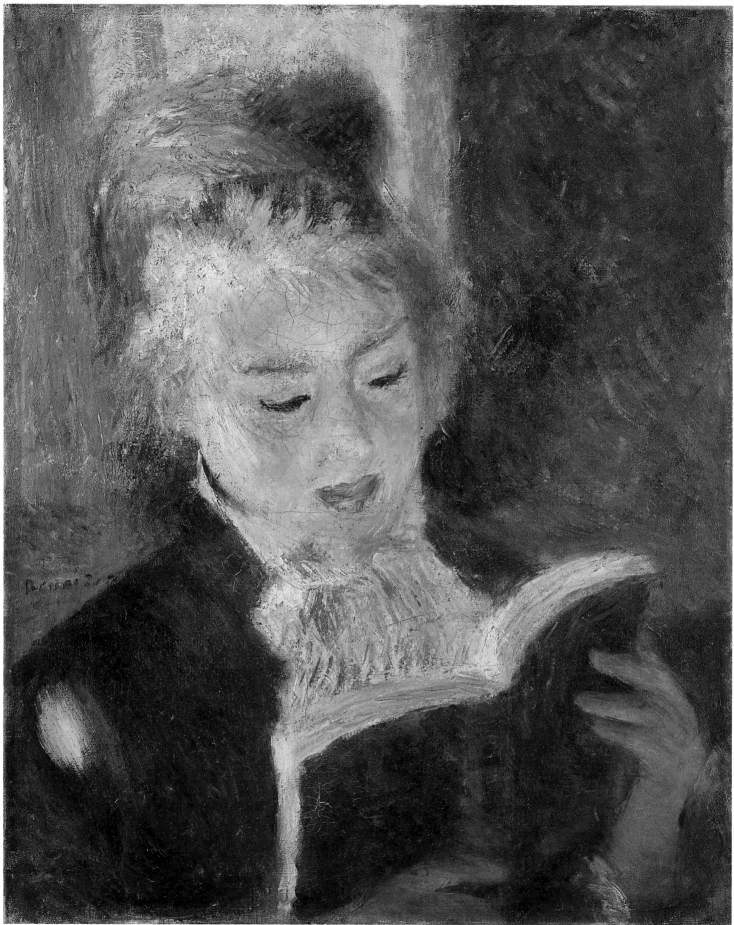

Pierre-Auguste **Renoir** ▪ *La Liseuse (The Reader)*, c. 1874–1876 ▪ 46.5 × 38.5 cm

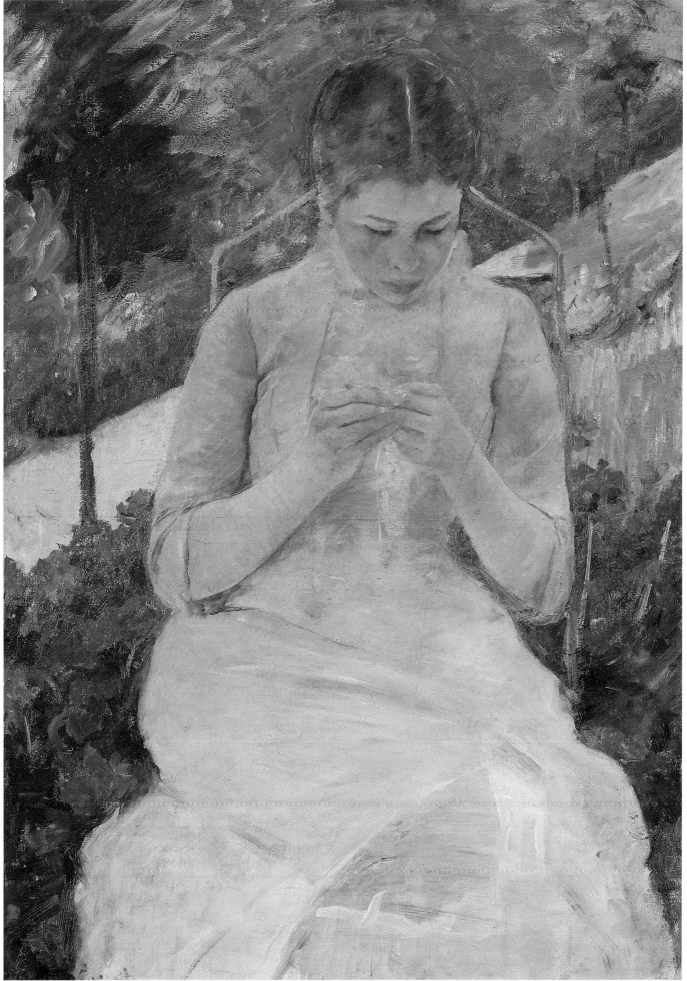

Mary **Cassatt** (1844–1926) ▪ *Femme cousant* (*Woman sewing*), c. 1880–1882 ▪ 92 × 63 cm ▪ 8th Impressionist exhibition, 1886

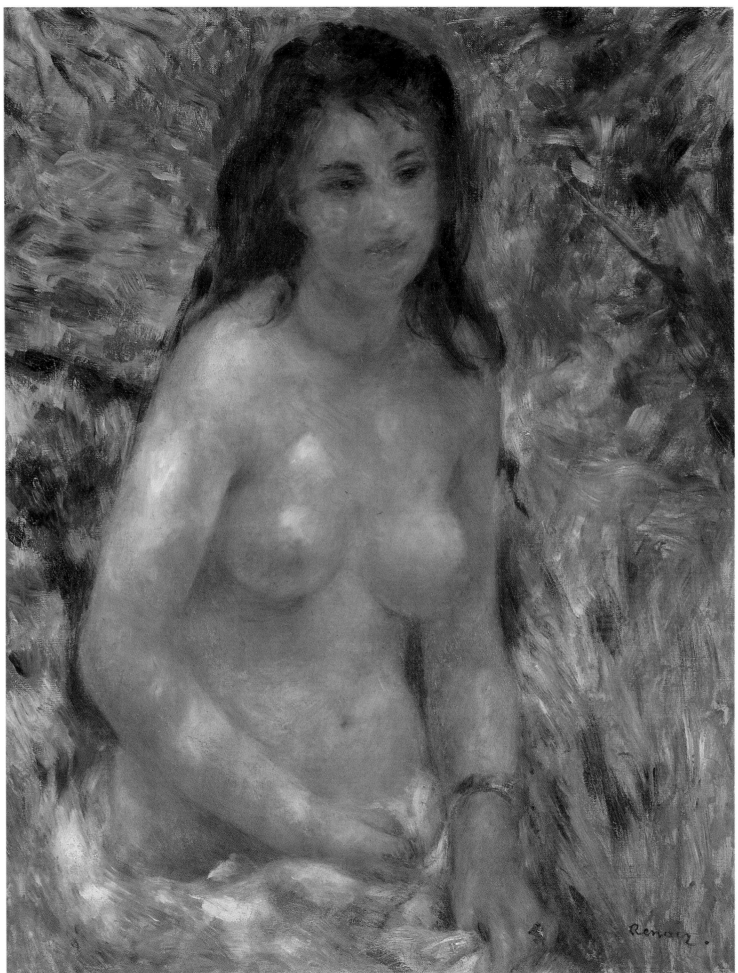

Pierre-Auguste **Renoir** ▪ *Étude. Torse, effet de soleil (Nude in the Sunlight)*, c. 1875–1876 ▪ 81 × 65 cm ▪ 2nd Impressionist exhibition, 1876

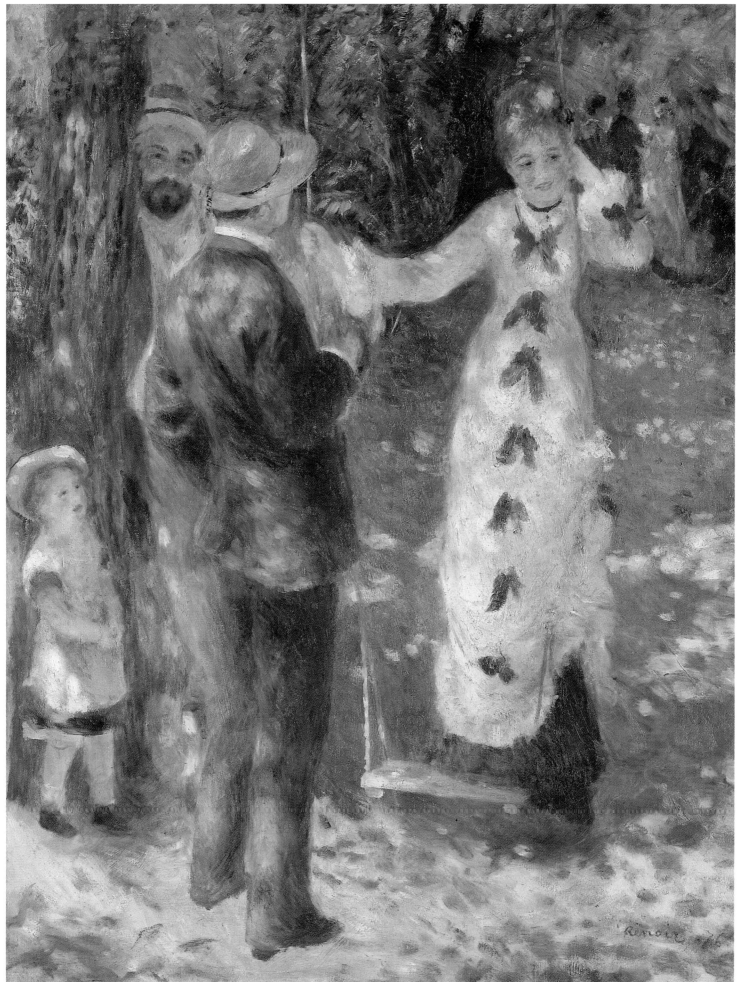

Pierre-Auguste **Renoir** ▪ *La Balançoire (The Swing)*, 1876 ▪ 92 × 73 cm ▪ 3ʳᵈ Impressionist exhibition, 1877

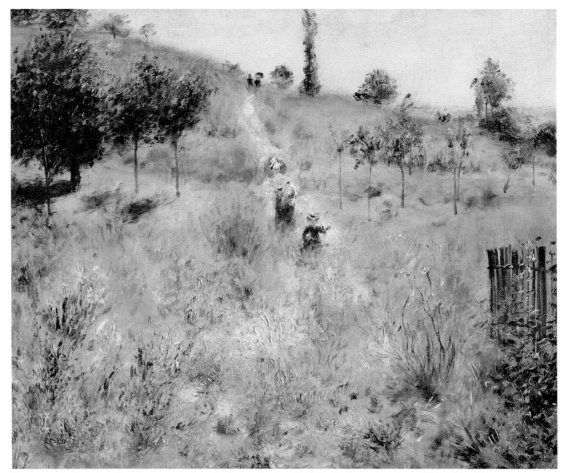

Pierre-Auguste **Renoir** ▪ *Chemin montant dans les hautes herbes (Path in the Long Grass)*, c. 1875 ▪ 60 × 74 cm

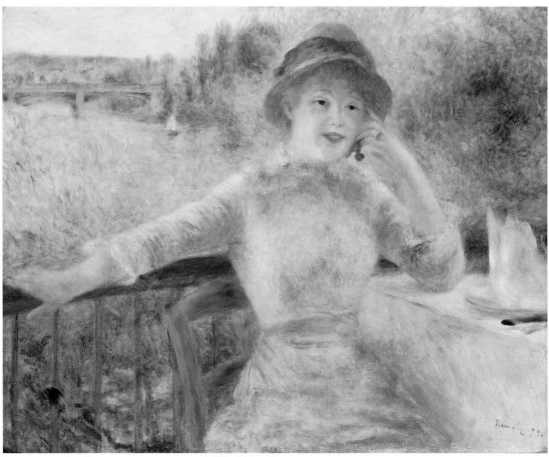

Pierre-Auguste **Renoir** ▪ *Alphonsine Fournaise*, 1879 ▪ 73.5 × 93 cm

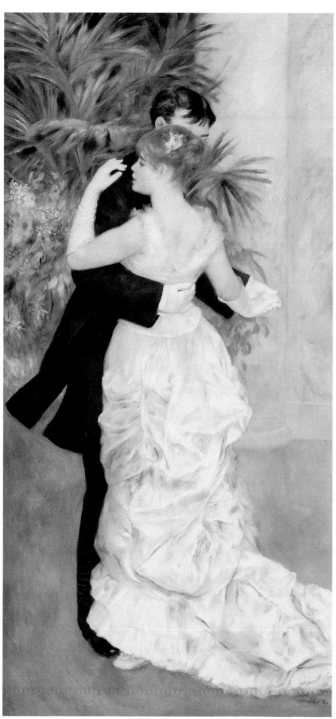

Pierre-Auguste **Renoir** ▪ *Danse à la ville (Dance in the City)*, 1883
▪ 181 × 90 cm

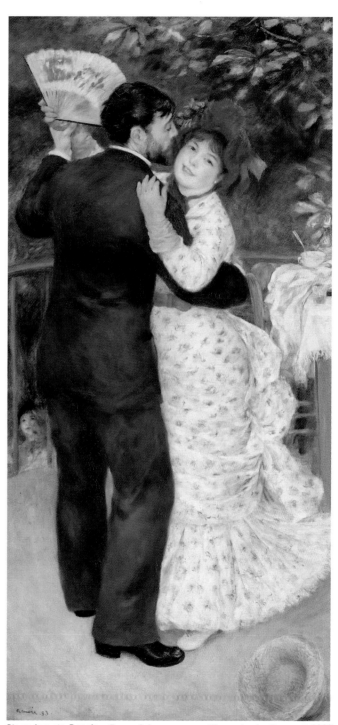

Pierre-Auguste **Renoir** ▪ *Danse à la campagne (Dance in the Country)*, 1883
▪ 181 × 90 cm

Le Déjeuner ; panneau décoratif
(The Luncheon; decorative panel)
c. 1873 ▪ 160 x 201 cm ▪ 2nd Impressionist exhibition, 1876

Claude **Monet** 1840 - 1926

Monet painted this picture in the garden of his house in Argenteuil, a little town on the outskirts of Paris, where he lived from 1871 to 1878. The summer scene it depicts shows us Jean, the painter's son, sitting in the shade of a table bearing the remains of an elegant lunch. In the background, two charmingly dressed young women, one of whom is probably Camille, Monet's wife, are passing by. The flowers are in bloom, the light is dazzling and trappings of women's lives lie here and there.

Le Déjeuner was shown at the second Impressionist exhibition of 1876 as a decorative panel. The format is important and is in keeping with the painter's early ambitions, the colours are fresh and bright and the subject portrayed is an ideal image of carefree family happiness. Monet appears to be seeking a new way forward for Impressionism, that of decoration, and a new outlet for his work, the middle-class homes of the Third Republic. It seems that when Ernest Hoschédé, a rich patron of the Impressionists, saw the work, he may have had the idea of commissioning Monet to paint the inside of his country house in Montgeron, for which *Les Dindons* (*The Turkeys*) was intended. Through its execution and graceful, intimate subject, *Le Déjeuner* is reminiscent of the decorations that the Nabi painters, and Vuillard in particular in his *Jardins publics* (*Public Parks*), would execute in the 1890s. It was also at the end of the 1890s that Monet threw himself into a new decorative project, that of the Water Lilies, to which he would devote thirty years of work and hundreds of paintings, including the *Nymphéas bleus* (*Blue Water Lilies*), and which would result in the grandiose series of the musée de l'Orangerie.

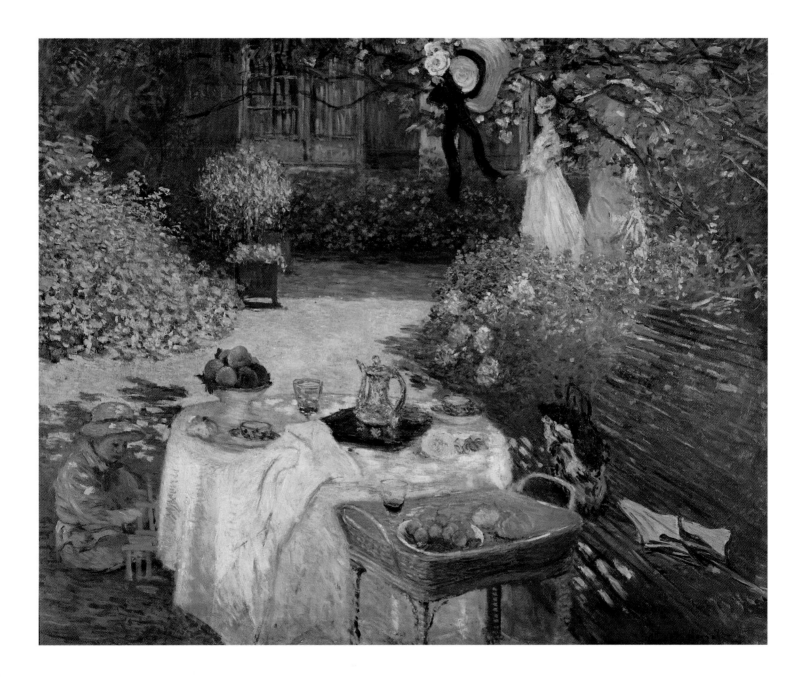

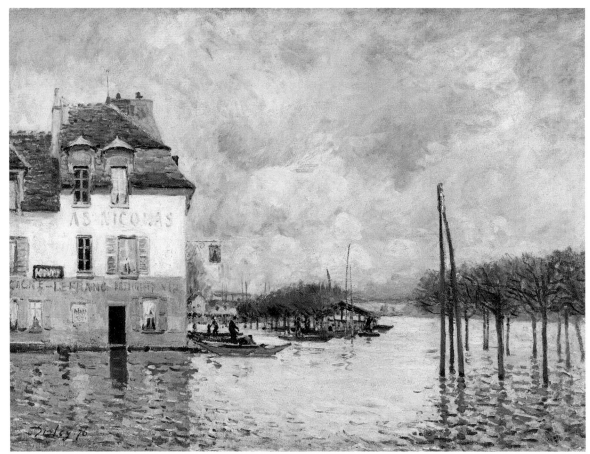

Alfred **Sisley** ▪ *L'Inondation à Port-Marly (Flooding at Port-Marly)*, 1876 ▪ 60 × 80 cm ▪ 2nd Impressionist exhibition, 1876

Alfred **Sisley** ▪ *La Neige à Louveciennes (Snow at Louveciennes)*, 1878 ▪ 61 × 50.5 cm

Claude **Monet** · *Coquelicots (Poppies)*, 1873 · 50 × 65 cm · 1st Impressionist exhibition, 1874

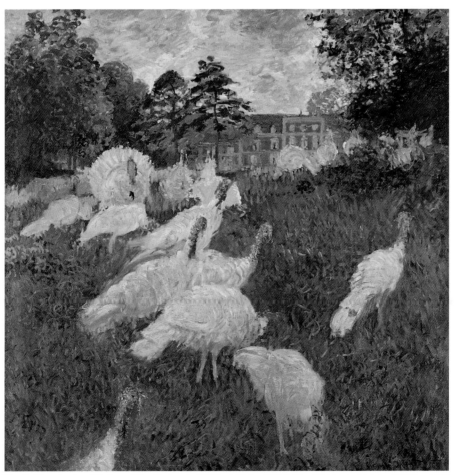

Claude **Monet** · *Les Dindons (The Turkeys)*, 1877 · 174.5 × 172.5 cm · 3rd Impressionist exhibition, 1877

Les Régates à Molesey
(Boating at Molesey)

1874 ▪ 66 x 91.5 cm

Alfred **Sisley** 1839 - 1899

Leisure was the great conquest of the 19th century and regattas figure prominently among the leisure pursuits beloved of the Impressionists. They prized their dazzling colours, moving reflections and noisy animation. Caillebotte, Renoir, Manet and Monet all captured these moments of modern revelry, but Sisley brought them a personal note. Like his fellow Impressionists, he delighted in painting the sky, the water and the momentum of the race accentuated by the waving flags and the gestures of the spectators watching from the banks. But he also knew how to capture the sweetness of the damp, grey English countryside under a cloudy sky. This balance of colour and composition characterised the work of Sisley, who was less daring that his fellow painters, and less determined to revolutionise the art of landscape painting, yet more inclined to render the permanent clemency of the changing weather. He was also able to reveal the moments of balance and harmony between man and the world around him that make up the flavour of some of Impressionist painting.

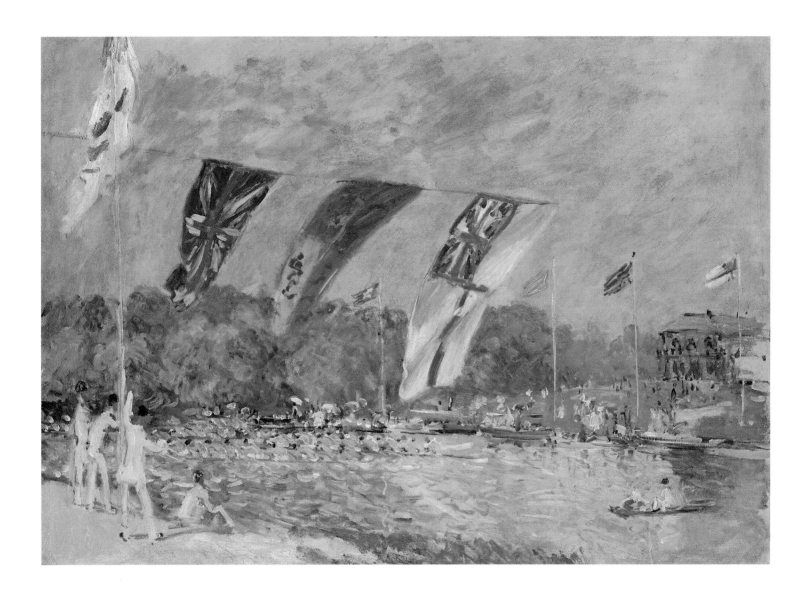

REBUILDING THE LANDSCAPE ▪ ▪ ▪ ▪

 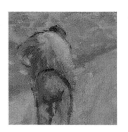

Coteau de l'Hermitage, Pontoise
(Hermitage Hill, Pontoise)
1873 ▪ 61 x 73 cm

Camille **Pissarro** 1830 · 1903

After Pissarro moved to Pontoise in 1866, a small group of painters, one of whom was Cézanne, formed around him. They were all looking for rustic landscapes untouched by the changes brought about by galloping industrialisation. They listened to the advice of Pissarro, who was carrying on the tradition of a rigorously structured landscape that he had himself inherited from a study of the works of Corot, whose pupil he called himself. *Coteau de l'Hermitage*, which was shown at the first Impressionist exhibition of 1874, reveals, alongside Monet's Impressionism, which tended entirely towards the representation of the moment, another way of seeing and thinking about the landscape. While the painting captures a particular aspect of the countryside in the cold light of a spring morning, many elements combine to make it timeless. Pissarro stresses the rustic architecture of the houses huddled on the hillside, while the latter, massive and heavy, takes up all the picture and leaves only a tiny part of the composition for the sky. He chose muted colours for the painting, which gives pride of place to the traditional activities of the countryside that Millet before him had so loved to paint – the fields with their orderly furrows, the vegetable patches and the slow pace of a countryman carrying a bundle of wood on his back. By his side, Cézanne learned to keep a check on his imagination and to impose Pissarro's strict principles on his brush.

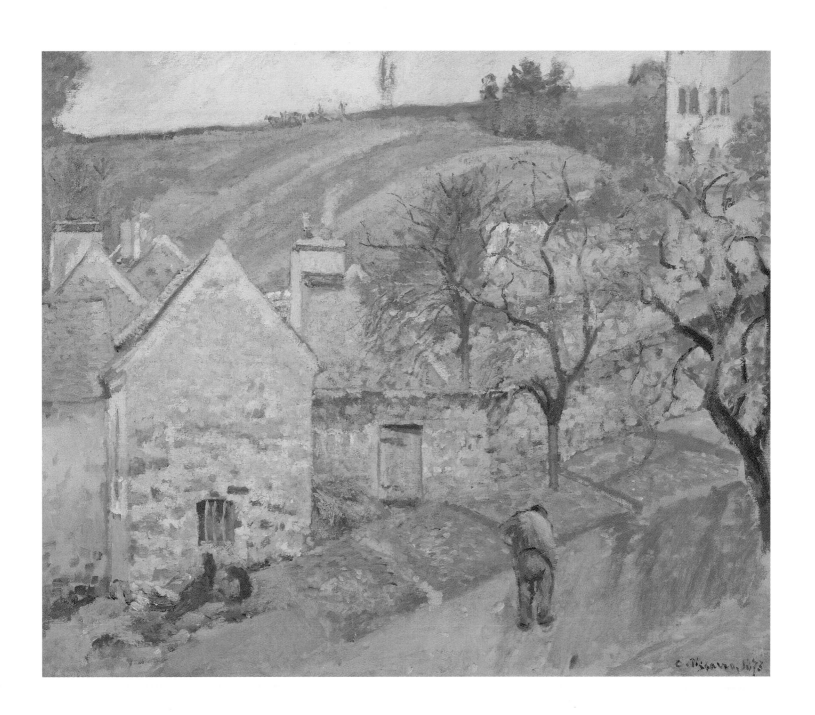

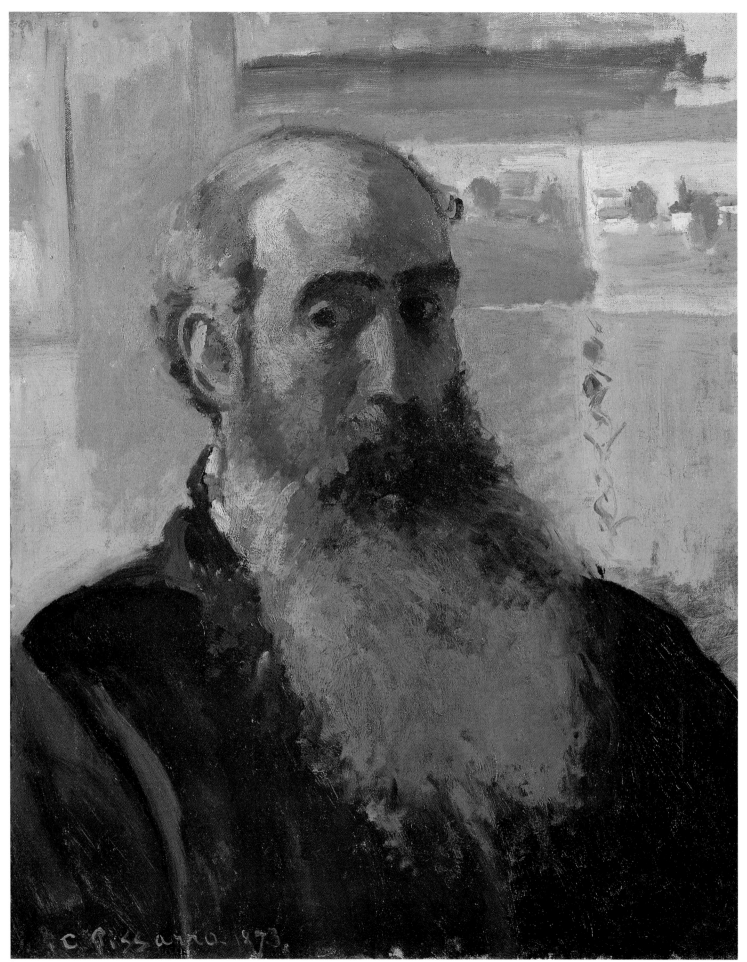

Camille **Pissarro** ▪ *Portrait de l'artiste (Portrait of the Artist)*, 1873 ▪ 56 × 46.7 cm

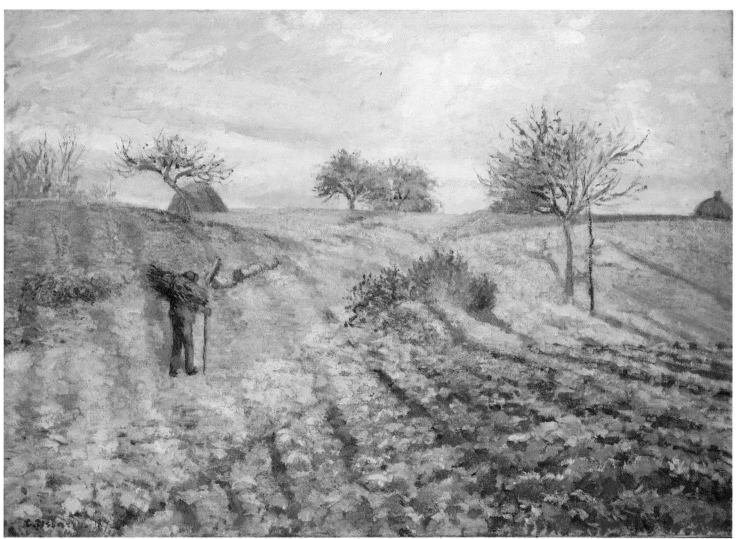

Camille **Pissarro** ▪ *Gelée blanche (Hoar Frost)*, 1873 ▪ 65 × 93 cm ▪ 1st Impressionist exhibition, 1874

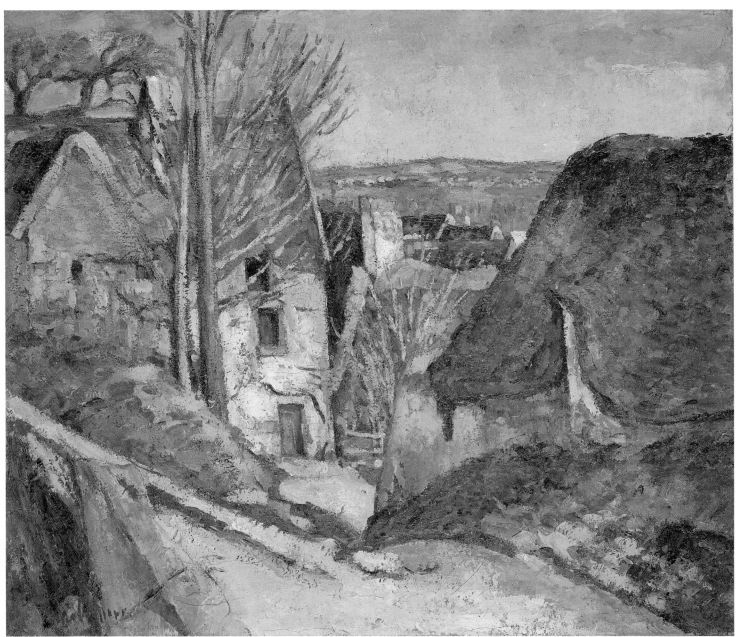

Paul **Cézanne** ▪ *La Maison du pendu (The House of the Hanged Man)*, 1873 ▪ 55 × 66 cm ▪ 1st Impressionist exhibition, 1874

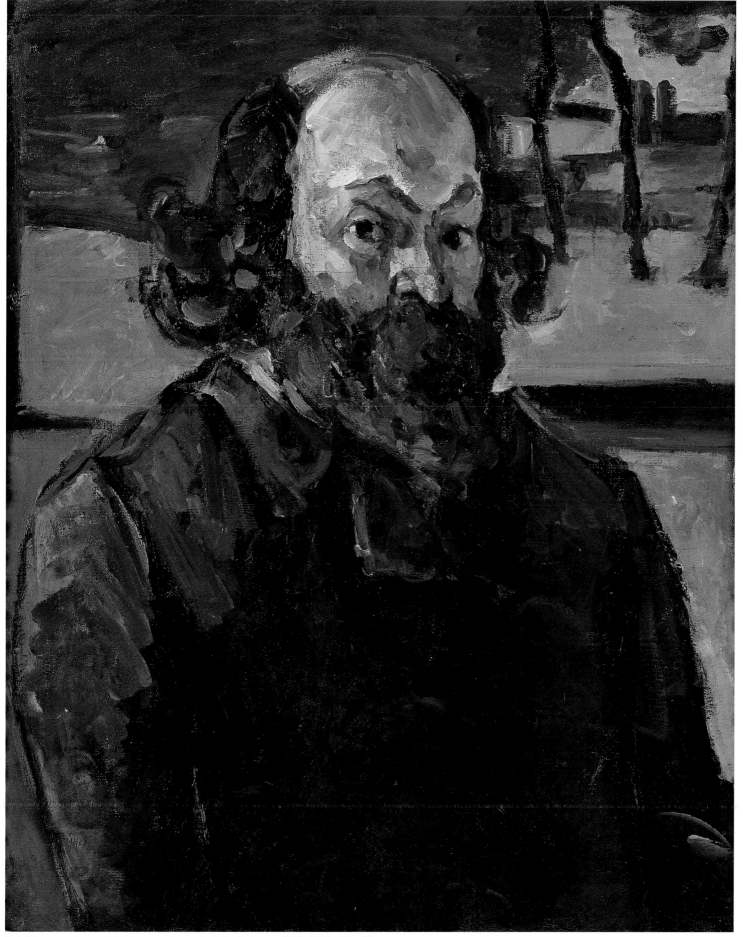

Paul **Cézanne** ▪ *Portrait de l'artiste (Portrait of the Artist)*, c. 1873–1876 ▪ 64 × 53 cm

Le Pont de Maincy
(The Bridge at Maincy)
c. 1879 ▪ 58.5 x 72.5 cm

Paul **Cézanne** 1839 - 1906

In 1876, Cézanne distanced himself from Auvers-sur-Oise and Pissarro in order to explore alone, in Provence and outside Paris, the new avenues opened up by the discoveries he had made while working on this subject in the wake of his friend. During these years, he learnt to curb his literary and imaginative excesses and always to refer back to the truth of nature. While Monet was turning to more and more transient subjects executed more and more rapidly, he embarked on the reconstruction of the Impressionist landscape. This involved a change of brush stroke, which is also found in *Les Peupliers* (*The Poplars*), in which the subject is built up by means of regular, radiating inflections, which also give the painting its unity. It involved, too, the choice of subjects, which avoid both the passing manifestations of modern life and the picturesque and topographical reproductions of rural landscapes favoured by Pissarro. For this reason, the subject of *Le Pont de Maincy*, which is situated in the Melun region and has been much simplified, was difficult to identify. The painter has concentrated on the essential elements of the landscape: a few timeless buildings, the safe, compact water, and nature itself, massive yet sensual and vibrant.

Paul **Cézanne** ▪ *L'Estaque, vue du golfe de Marseille* (*L'Estaque Seen from the Gulf of Marseilles*), c. 1878–1879 ▪ 59.5 × 73 cm

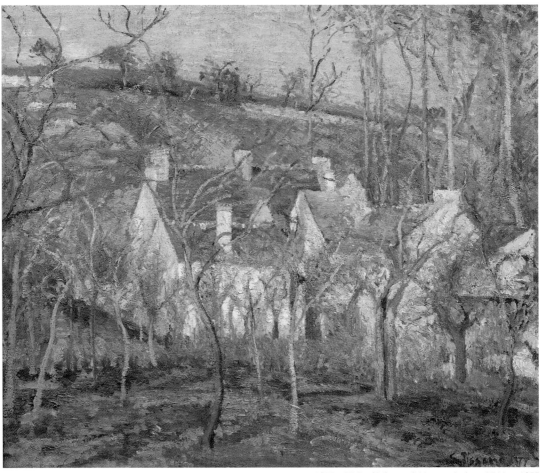

Camille **Pissarro** ▪ *Les Toits rouges, coin de village, effet d'hiver* (*Red Roofs*), 1877 ▪ 54.5 × 65.6 cm ▪ 3rd Impressionist exhibition, 1877

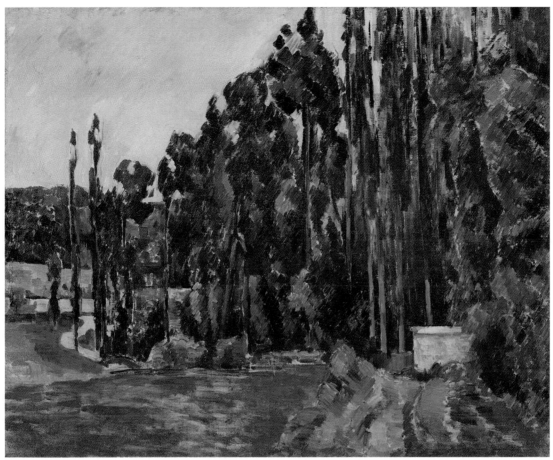

Paul **Cézanne** ▪ *Les Peupliers (The Poplars)*, c. 1879–1882 ▪ 65 × 81 cm

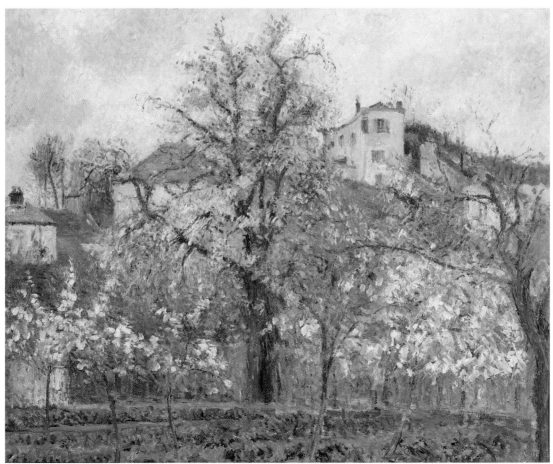

Camille **Pissarro** ▪ *Printemps. Pruniers en fleurs (Springtime. Plum Trees in Blossom)*, 1877 ▪ 65.5 × 81 cm ▪ 4th Impressionist exhibition, 1879

La Gare Saint-Lazare
(Saint-Lazare Station)
1877 ▪ 75.5 x 104 cm ▪ 3rd Impressionist exhibition, 1877

Claude **Monet** 1840 - 1926

Monet painted twelve different views of the Saint-Lazare railway station, a monument to modernity in the heart of the city. He was not the first painter to roam about the stone and metal monster that had changed the face of one of Europe's most elegant districts. Manet and Caillebotte had also been intrigued by the massive station and its railway tracks but had stopped short at the entrance, going neither through the gates nor over the parapets. Monet, on the other hand, went down into the inspection pit, confronted the locomotives and faced the flood of travellers that poured out of the largest station in Paris every day. He managed to catch the play of light and steam imprisoned beneath the vault, capture the colours of the surrounding buildings and the slow movement of the powerful engines, and invent a new kind of landscape, the modern urban landscape. Zola was struck by the force of Monet's paintings when they were shown at the group's third exhibition in 1877 and wrote: "Monet has shown marvellous station interiors this year. You can hear the grinding of the trains entering them and see the clouds of smoke rolling under the vast roofs. This is where painting is today… Our artists must find poetry in stations, as their fathers found it in forests and rivers."

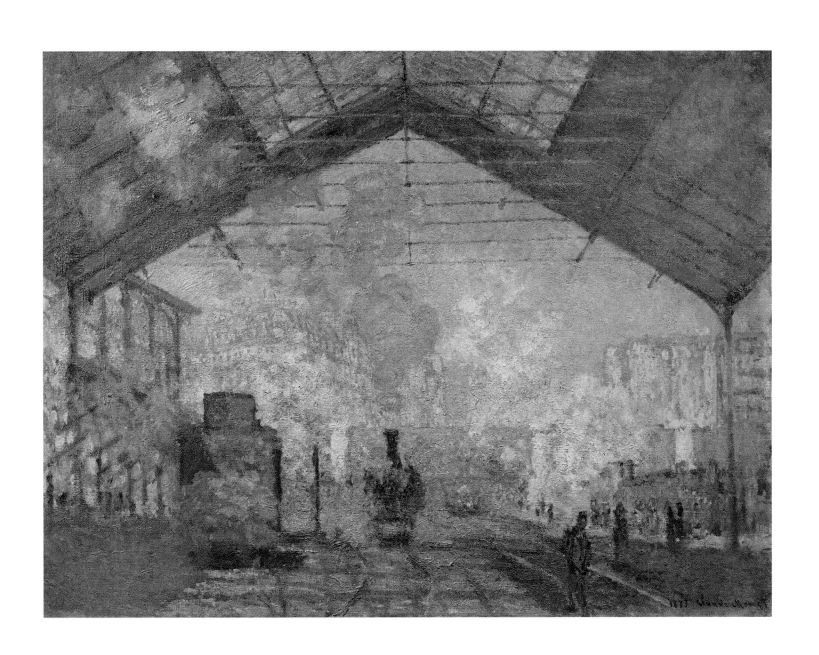

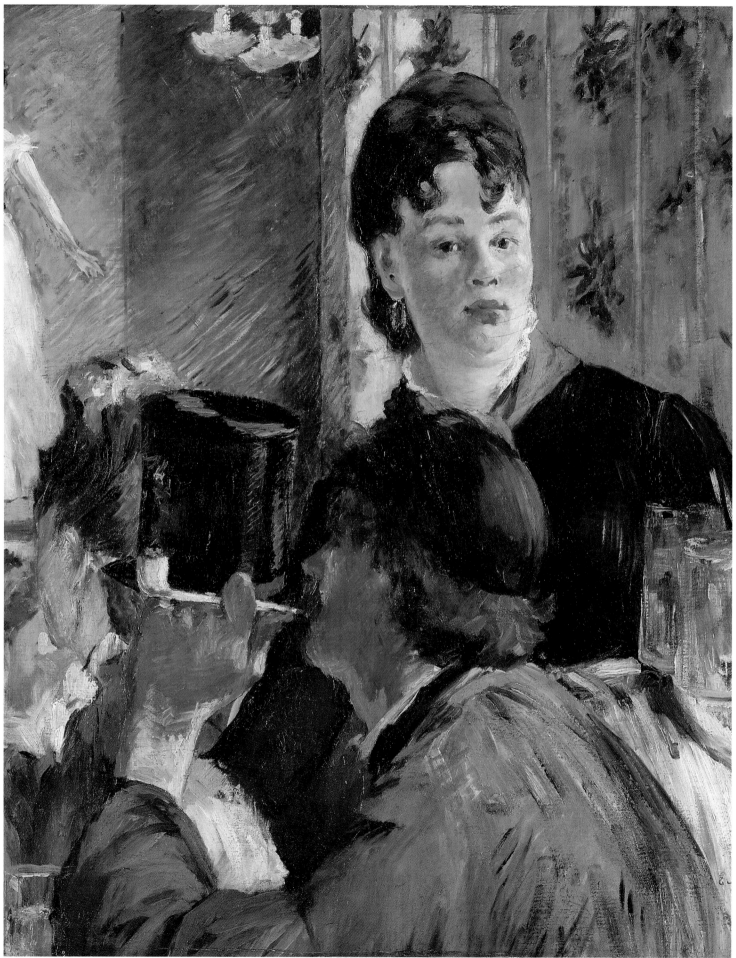

Édouard **Manet** ▪ *La Serveuse de bocks* (*Woman Serving Beer*), 1878–1879 ▪ 77.5 × 65 cm

Claude **Monet** ▪ *La Rue Montorgueil, à Paris, Fête du 30 juin 1878 (Rue Montorgueil, Decked out with Flags, 30 June 1878)*, 1878
▪ 81 × 50.5 cm ▪ 4th Impressionist exhibition, 1879

Bal du Moulin de la Galette, Montmartre (Dancing at the Moulin de la Galette)

1876 ▪ 131 x 175 cm ▪ 3rd Impressionist exhibition, 1877

Pierre-Auguste **Renoir** 1841 - 1919

"The painter has accurately rendered the rowdy and slightly disreputable atmosphere of this café and dance hall, possibly the last of its kind in Paris. The dancing takes place in the meagre little garden next to the Moulin...," wrote one of Renoir's favourable critics when the painting was shown at the third Impressionist exhibition of 1877. The picture is one of the most ambitious that Renoir painted in the 1870s. In it, he tried to reconcile the grand principles of modernity, by rendering a faithful account of a café dance, with those of Impressionism, by painting his picture in the open air, all this on a large-scale canvas. To these two challenges, Renoir added that of conveying the hectic rhythm of the dance. To succeed in this bold enterprise, the painter called on the help of a few of his friends and of models he found in Montmartre, where he lived at the time. He used them to compose the scene in the foreground, in which people are chatting happily round a table. Then he placed a few clasping couples, who become more and more anonymous the further back you go in the picture. The patches of light randomly piercing the coloured shade, the vanishing perspective and the apparently rising ground are all elements that combine to create the impression of hubbub and whirl that Renoir was trying to give to his picture. The spontaneous, luminous and joyful nature of the work made it one of the icons of Impressionnism and founded a whole mythology of late 19th-century life in which Renoir himself wished to believe. Montmartre was by now already beginning to lose its semi-rural character and, with the painful memory of the Commune in mind, to live to the rhythm of the capital that came right up to its doorsteps.

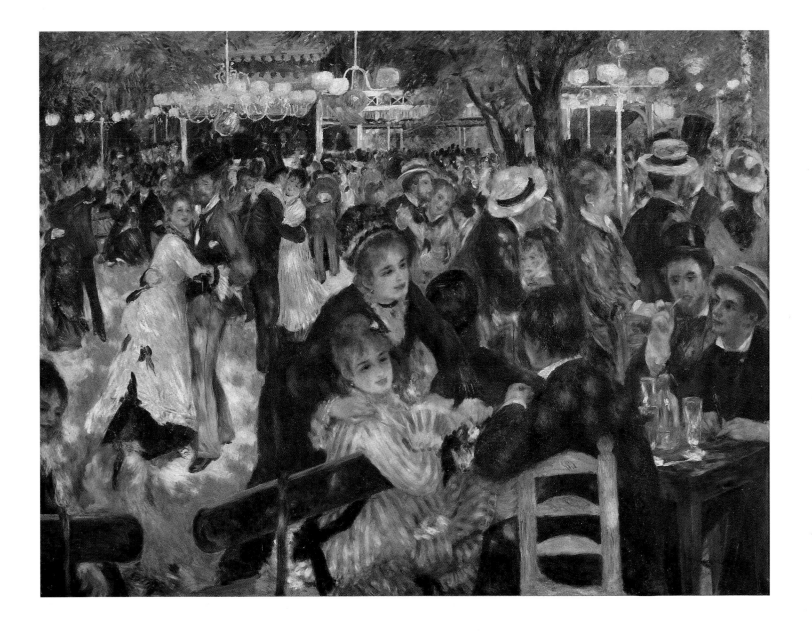

Dans un café, also known as *L'Absinthe (Absinth)*

c. 1875–1876 ▪ 92 x 68 cm ▪ 2nd Impressionist exhibition, 1876

Edgar **Degas** 1834 - 1917

Alcoholism was probably one of the worst scourges of the late 19th century, taking its place alongside prostitution as one of the dark sides of modern life. It fell to artists to bear witness to its unspeakable pain and to denounce an insidious evil. Degas, the intransigent realist of the Impressionist group, thus became one of the first to look it squarely in the face and represent it in all its brutal reality. He painted a man and a woman, not anonymous Parisians chosen at random from the terraces, but two friends who have ended up in a café, the Nouvelle-Athènes, one of the Impressionists' meeting places. The woman, Ellen Andrée, a quite well-known model, has a glass of absinthe in front of her. The man, the engraver Marcellin Desboutins, who has been given a less strong drink, is lost in the smoke from his pipe. When the painting was shown at the second Impressionist exhibition of 1876, Degas stressed that it was a sketch to forestall any criticism regarding its unfinished appearance. The execution is indeed vigorous but loose and hasty. The woman's dress seems neglected and Degas took pains to render the faces allusively. The completely eccentric composition inspired by the Japanese prints that Degas much admired, reinforces the impression of spontaneity conveyed by the painting. The technique matches the artist's intimacy with his models and corresponds to his parallel research into monotypes, whose freedom of execution allowed him to explore the capital's places of leisure and pleasure (*cafés-concerts*, boulevards and brothels). It also effectively portrays the degradation of the two characters.

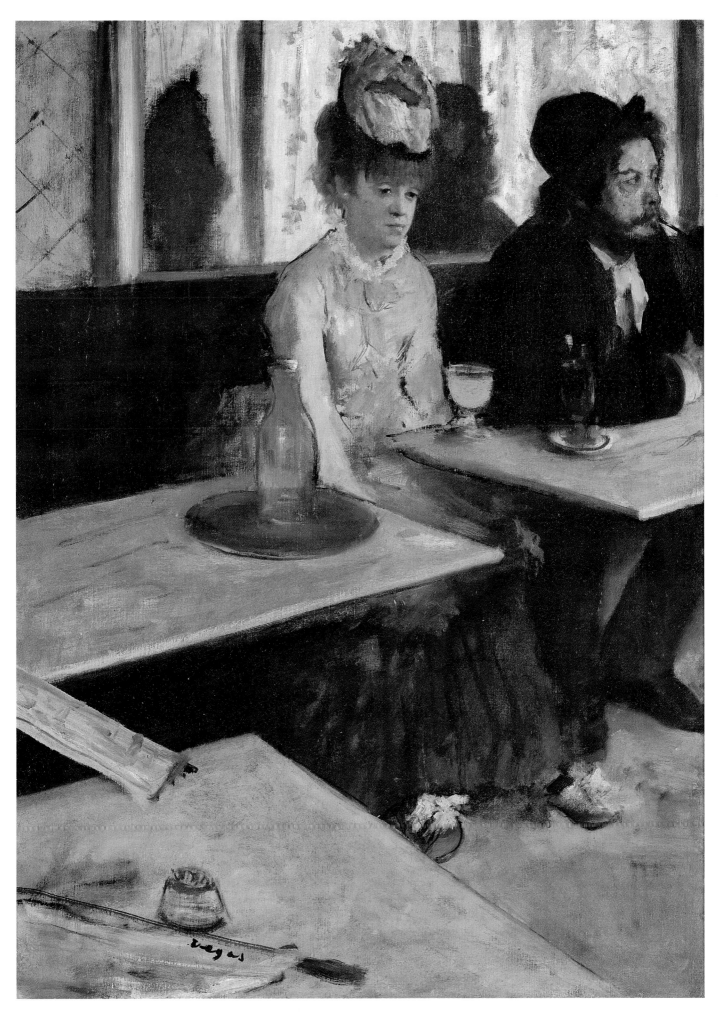

Les Raboteurs de parquet
(Planing the Floor)
1875 ▪ 102 x 146.5 cm ▪ 2nd Impressionist exhibition, 1876

Gustave **Caillebotte** 1848 - 1894

Caillebotte made a notable entrance into the group of independents when he showed this large painting at the second Impressionist exhibition of 1876. The work had been refused at the preceding Salon, probably because of its openly realist character, its refusal of any form of idealisation and the complete banality of its subject. These are the very criteria that placed it at the heart of Impressionist preoccupations and brought to the movement a modernist and social dimension it had hitherto been lacking. The strength of Caillebotte's painting lies in its unusual blend of highly polished execution, slightly theoretical perspective, academic poses, and an everyday subject studied with almost clinical curiosity. The critics were struck by his originality but it troubled Zola, who saw it merely as a "carbon copy of the truth". The following year, Caillebotte pursued his exploration of the Parisian life of both the streets and in its apartments in large canvases exhibited at the third Impressionist exhibition of 1877. By his boldness and generosity, Caillebotte supported the realist experiments of his Impressionist friends. He stimulated Monet in his exploration of modern landscapes in the late 1870s and was one of the first to buy a *Gare Saint-Lazare* in 1877. In the same year, he also acquired *Bal du Moulin de la Galette* (*Dancing at the Moulin de la Galette*), Renoir's broad, dynamic canvas of modern life. Renoir, who was Caillebotte's executor, chose *Les Raboteurs de parquet* to represent the painter and patron of the arts and his realist passion at the musée du Luxembourg and later at the Louvre.

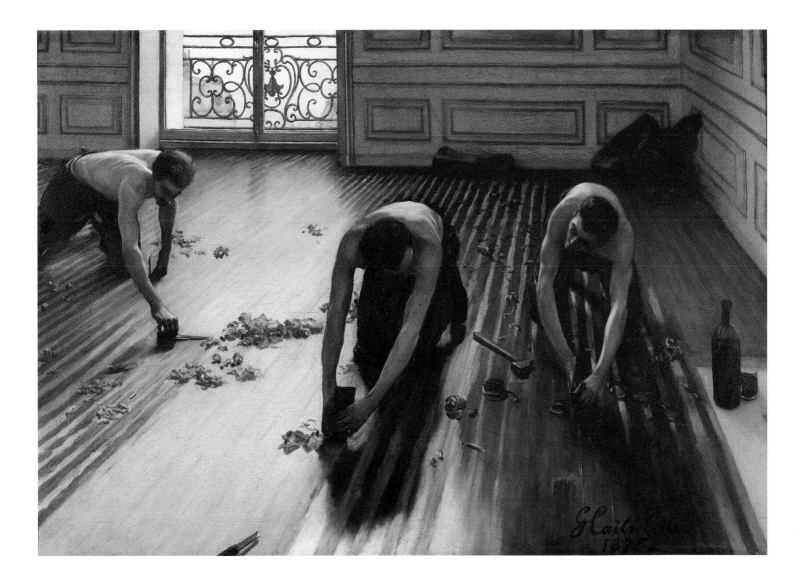

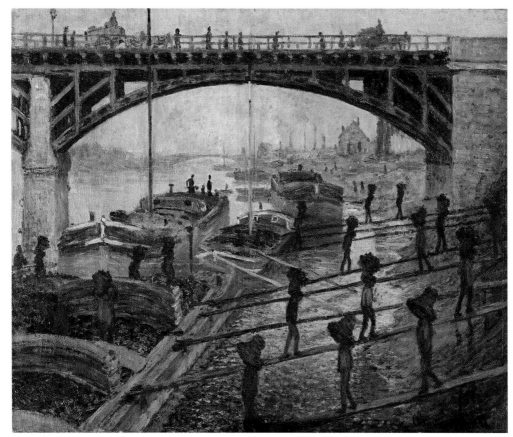

Claude **Monet** ▪ *Les Déchargeurs de charbon* (*Unloading the Coal*), c. 1875 ▪ 55 × 66 cm ▪ 4th Impressionist exhibition, 1879

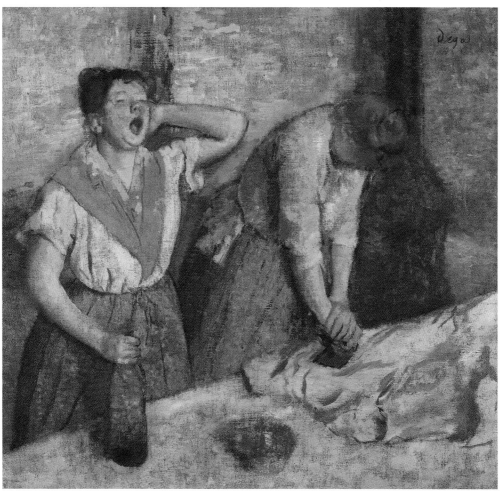

Edgar **Degas** ▪ *Repasseuses* (*Women Ironing*), c. 1884–1886 ▪ 76 × 81.5 cm

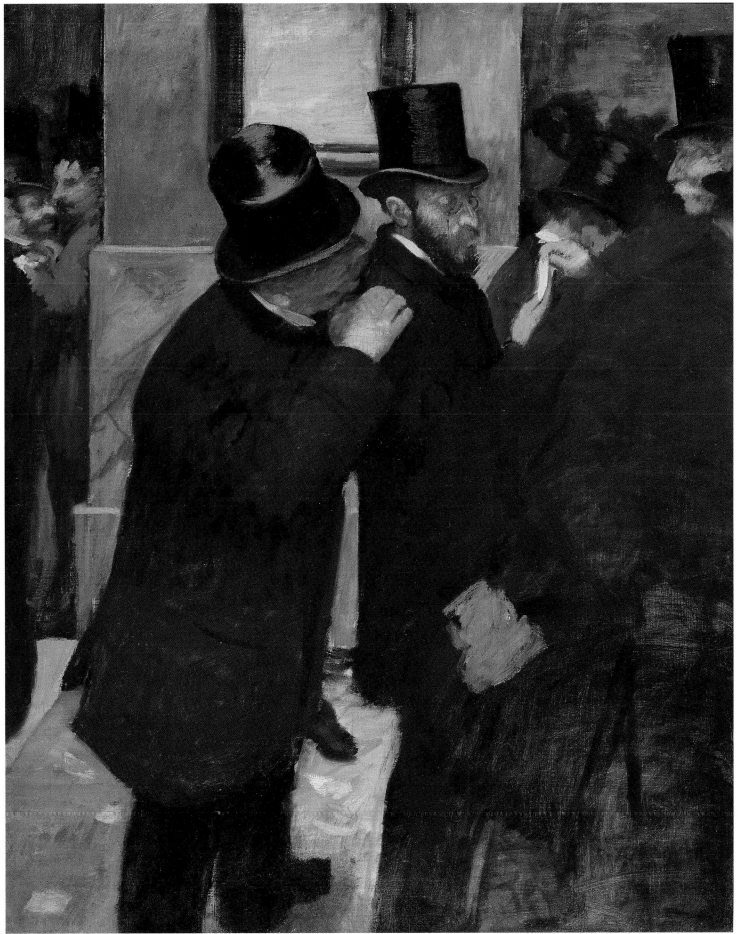

Edgar **Degas** ▪ *Portraits à la Bourse (Portraits at the Stock Exchange)*, c. 1878–1879 ▪ 100 × 82 cm ▪ 4th Impressionist exhibition, 1879

Petite danseuse de 14 ans
(Little Fourteen-Year-Old Dancer)

1881 ▪ 98 x 35.2 x 24.5 cm ▪ Bronze statue with a patina of various colours,
a tulle tutu and pink satin ribbon in her hair ▪ 6th Impressionist exhibition, 1881

Edgar **Degas** 1834 - 1917

The appearance of *La Petite Danseuse de 14 ans* at the sixth Impressionist exhibition of 1881 stupefied art lovers. The coloured wax statue, wearing some of the real attributes of the "little rats" (young dancers) of the Paris Opéra, was the first truly realist sculpture inspired by the wax statues of the museums of natural history and medicine. In its association of real elements and elements fashioned by the artist, it carries the germ of the 20th-century sculptors' boldness. Yet this revolutionary little figure is perfectly in keeping with Degas' preoccupations. Fascinated by the world of dance, he haunted the Opéra studio, attended rehearsals, followed the dancers' difficult careers and tirelessly drew their efforts, pain and exhaustion. The young girls he tracked from the stage to the wings embodied in his eyes the essence of Parisian life with its moments of beauty and many vices. It was in fact only a step from the arabesques of the dancers to the most sordid prostitution. Marie van Goethem, the model for the dancer, bore on her body the grace and perfection of years of work and on her face a stubborn brazenness that frightened the critics: "Why is her forehead..., like her lips, already marked by such a profoundly vicious character?" The gaze that Degas rested on the modern city and its inhabitants was sometimes cruel and always pessimistic.

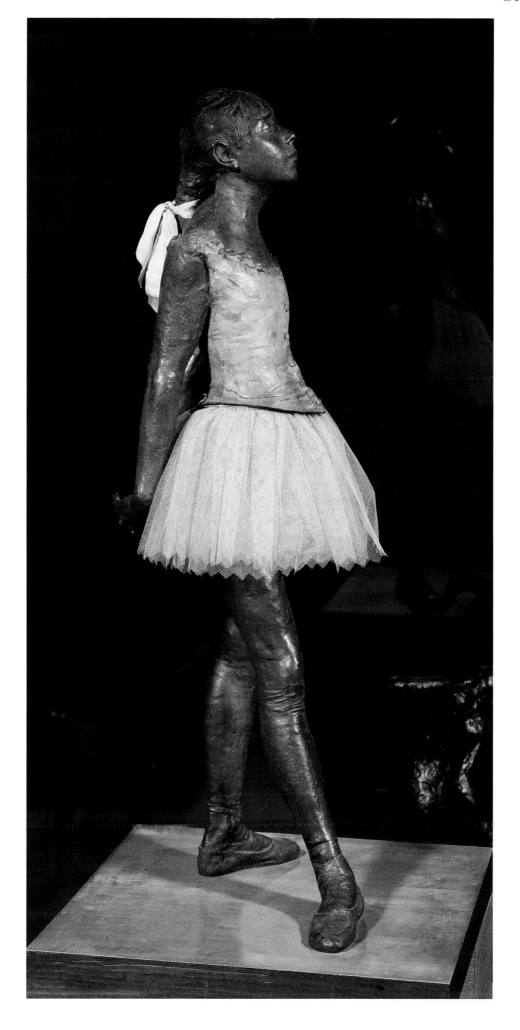

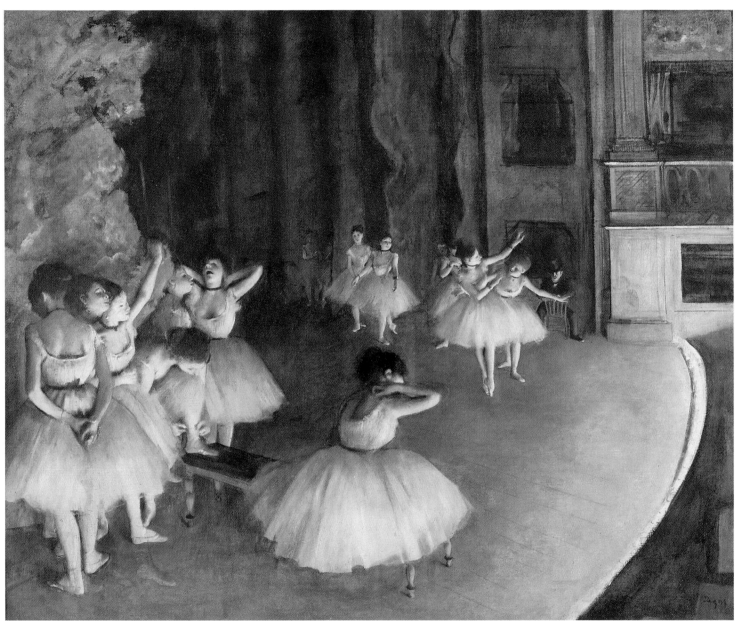

Edgar **Degas** ▪ *Répétition d'un ballet sur la scène* (*The Ballet Rehearsal on the Stage*), 1874 ▪ 65 × 81 cm ▪ 1st Impressionist exhibition, 1874

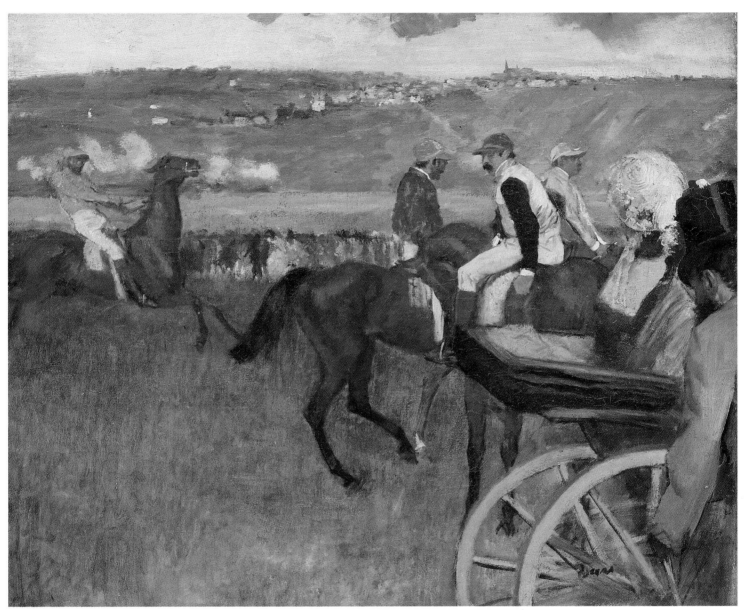

Edgar **Degas** ▪ *Le Champ de courses. Jockeys amateurs près d'une voiture* (*The Racetrack. Jockeys near a Carriage*), 1876–1887 ▪ 66 × 81 cm

 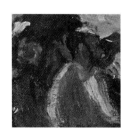

L'Évasion de Rochefort
(Rochefort's Escape)
1880–1881 ▪ 80 x 73 cm

Édouard **Manet** 1832 - 1883

In his constant search for heroes of his time and heroic episodes with which to renew historical painting, in 1880 Manet became interested in Rochefort, a journalist member of the Paris Commune who had been imprisoned in the penal colony of New Caledonia and who had escaped in 1874. The subject tempted Manet for two reasons. It allowed him to refer to the famous episode of the *Le Radeau de la Méduse* (*The Raft of the Medusa*), immortalised by Géricault in 1824, and it reminded him of his dreams of being a sailor and of adventure and the open sea. The poet Mallarmé, who had become a very close friend of the painter, supported him in a project about which he was enthusiastic, as Monet records: "I saw that Manet was very taken up with a plan for a sensational painting for the Salon, Rochefort's escape in a dinghy on the open sea." There are in fact two elements in the painting, the dinghy carrying away the six escaped convicts and the endless sea, which entirely dominates the composition and which returns the heroes to their narrow fate. Manet chose the opposite course to Géricault, who had given the lion's share to the shipwreck victims, and thus once again overturned the code of historical painting. Manet abandoned his hero, whom he in the end found disappointing, and glorified the sea in free, dense painting.

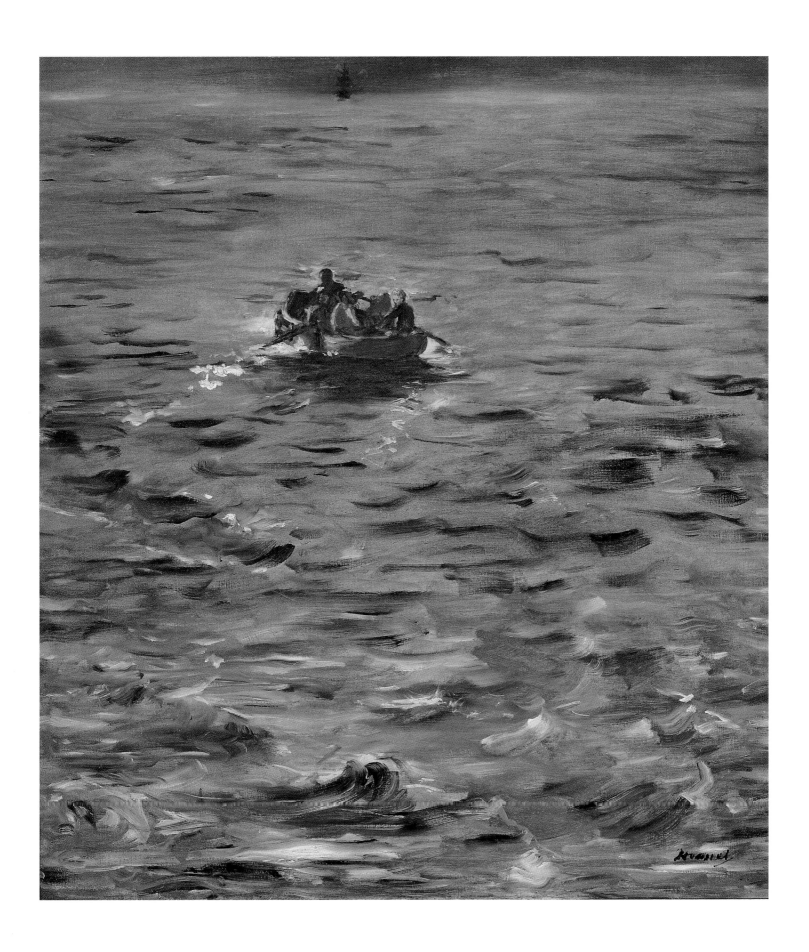

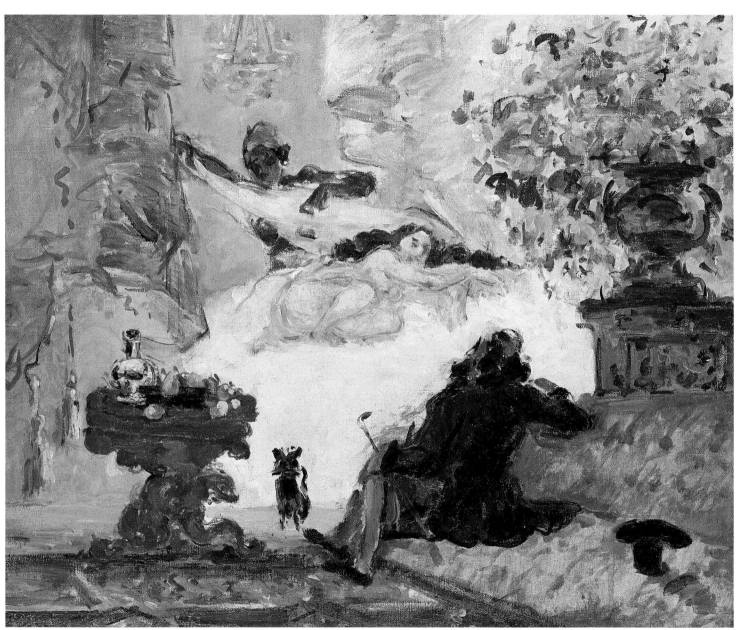

Paul **Cézanne** ▪ *Une moderne Olympia (A Modern Olympia)*, c. 1873–1874 ▪ 46 × 55.5 cm ▪ 1st Impressionist exhibition, 1874

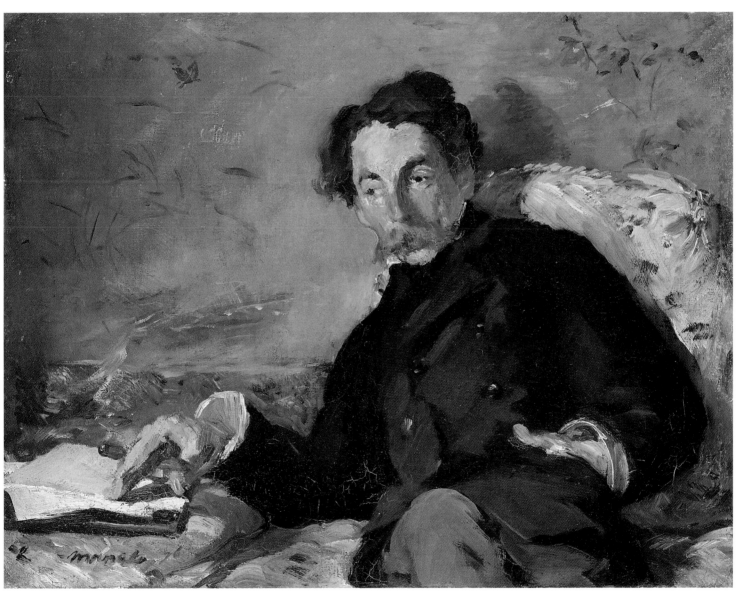

Édouard **Manet** ▪ *Stéphane Mallarmé*, 1876 ▪ 27.5 × 36 cm

La Tentation de saint Antoine
(The Temptation of St Anthony)
1875 ▪ 47 x 56 cm

Paul **Cézanne** 1839 - 1906

This small painting by Cézanne, which once belonged to the pastry cook Murer, an unusual collector of Impressionist paintings, is a synthesis of the painter's experiments of the mid 1870s. The subject is probably taken from the novel *La Tentation de saint Antoine* by Flaubert, a writer Cézanne much admired. A childhood friend of Zola's, the painter had a passion for literature that runs like a thread through the wild, darkly romantic works of his youth. The temptation of St Anthony is a theme Cézanne had already touched on in the late 1860s, at a time when he was preoccupied by the myth of woman as temptress. He probably still believed, like Manet, that historical and literary subjects could be treated in an innovative pictorial language. However, Cézanne did his best to curb his literary leanings (and wrote at the end of his life: "An artist must flee literature in art") by regular work on other subjects. This painting shows the effects of his open-air experiments in its light, luminous colours and broken brushstrokes, which are characteristic of the most Impressionistic phase of his work. And behind the literary temptation, which was soon overcome, and the Impressionist experimentation, two major themes of his later research can be seen in this work. The scene is set in a landscape that can easily be identified, with its white rocks and blue skies, as a landscape of the Provence that would completely occupy the painter's attention from the 1880s onwards, while the nude woman who is the central figure of the work is a sister to the bathers who would multiply and blossom into *Les Baigneuses* (*The Bathers*) that were his last works.

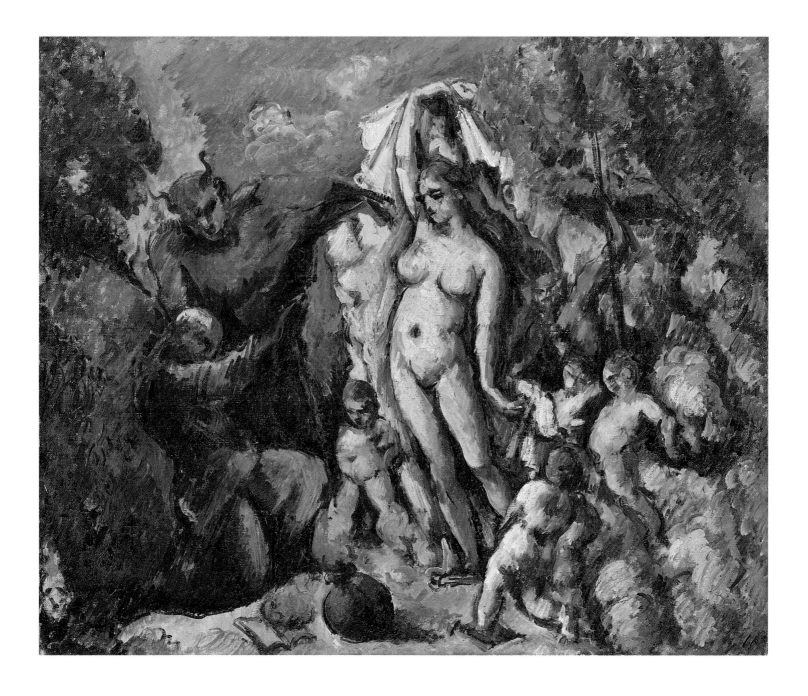

Impressionism after 1886

"Will I succeed in my chosen task?"

Cézanne

- SISLEY, IMPRESSIONISM PRESERVED

- PISSARRO, THE LAST BATTLES

- RENOIR, THE PLEASURE OF PAINTING

- MONET, THE TRIUMPH OF THE LANDSCAPE

- CÉZANNE, THE ESSENCE OF THINGS

- DEGAS, REFUSING THE EASY WAY

- MONET, PRIMORDIAL NATURE

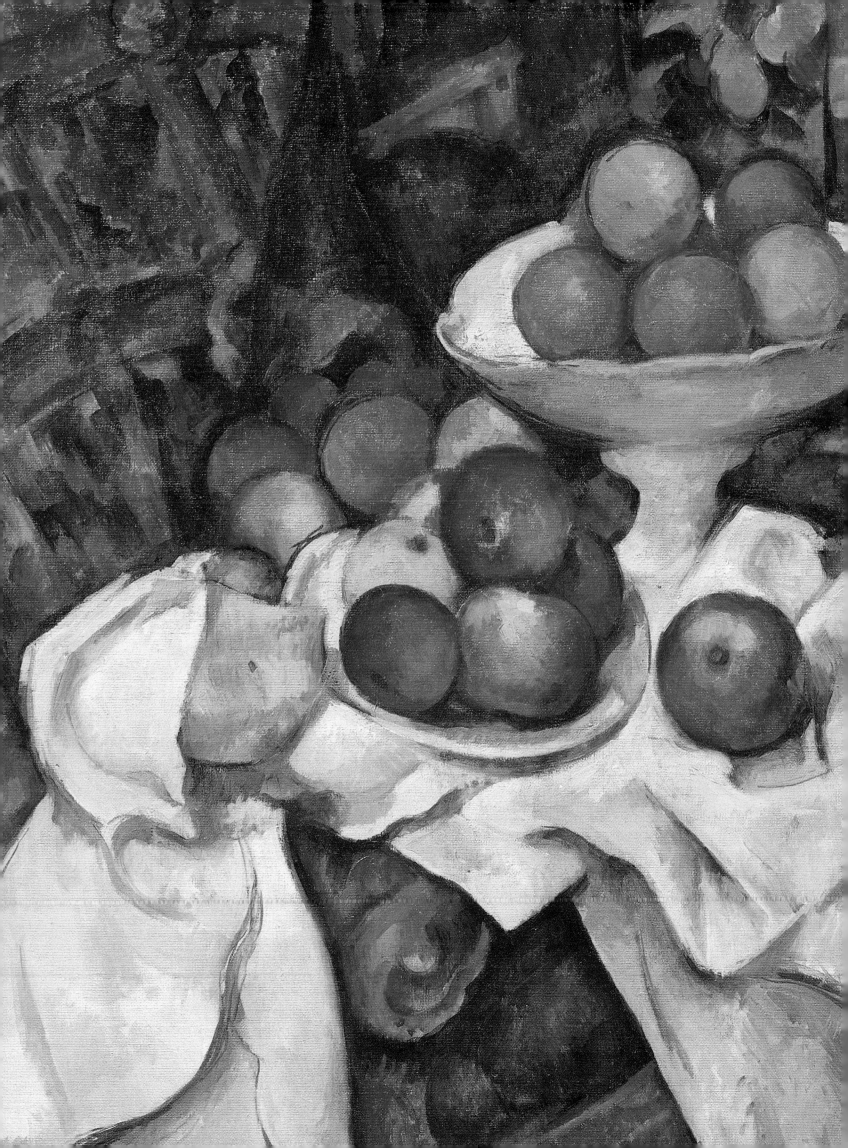

In about 1883, Renoir entered a period of extreme doubt, which he analysed a few years later for the dealer Vollard: "I had gone to the limits of Impressionism and had come to the conclusion that I could neither paint nor draw."

Although very radical in its expression and conclusions, Renoir's unease translated the difficulties experienced by each of the Impressionists after twelve years of struggle to gain acceptance for a style of painting born of camaraderie and the excitement of a great challenge. The break-up of the group confirmed Monet, Degas, Renoir and Cézanne in their chosen paths. It was much more of a problem for Sisley, who was shy and lonely, and for Pissarro, though he found the old emulation again among his neo-Impressionist friends.

The crisis also happened at a time when a new generation of painters was coming to the fore. These painters, indebted to the Impressionists for the new-found independence they were now able to enjoy and for the freedom of colour, shape and subject they exploited, claimed to go further than their elders. At this time of emerging Symbolism, the Impressionists were reproached for their lightweight subjects, which Gauguin, even though he came from their ranks and was an avid observer of the work of Pissarro and Cézanne, summed up in the following way: "They study colour exclusively as a decorative effect, but without freedom, remaining within the bounds of probability. They search around the eye and not at the mysterious centre of thought." The Impressionists, and Monet in particular, who embodied Impressionism in everyone's

eyes, were also reproached for a lack of construction and the elimination of shapes. These accusations coincided with Renoir's insecurity about his drawing, Cézanne's ambitions which tended towards making "Impressionism a solid art like that of museums" and the pointillist experiments of Pissarro; all at a time when the representation of the human form was again becoming the priority of some of the artists.

Renoir's doubts surfaced when he realised that he was first and foremost "a painter of the human form". From then on, he concentrated on portraits, nudes, a few family scenes and others of everyday life in the city or country, and his ambitions sometimes coincided with those of Degas, who chronicled modern life. While Renoir placed greater emphasis on drawing, he never questioned the fundamental contribution of the Impressionism he had experienced at Monet's side, and sometimes even with Cézanne: the permeability of people and objects to the surrounding atmosphere. After several precisely drawn and ambitiously constructed works, Renoir yielded to the sensual and sometimes fanciful intuitions that guided the execution of his various *Jeunes filles au piano* (*Young Girls at the Piano*) and many nudes.

An overwhelming preoccupation with the human form was also what brought Pissarro closer to neo-Impressionism. His *Jeune fille à la baguette* (*Young Girl with a Stick*), with its emphasis on a graceful and poetical human form, had revealed the new direction Pissarro's work was taking. Pissarro was following the example of Seurat, who had succeeded in reconciling the

monumental and heroic representation of human activities with a very modern representation of the landscape. Until his rapid break with theories he found too rigid, he painted a number of surreptitiously Symbolist compositions with flowing, decorative rhythms. Alongside this "Arcadian" vein, which Cézanne was also exploring in a different manner, Pissarro developed a whole series of urban views. As a countryman ever surprised by the brutal and inevitable industrialisation of the cities, Pissarro painted the milling crowds of the streets of Paris and the smoke of the port of Rouen.

In answer to the question of the human form, which haunted his old companions, Renoir and Pissarro, and that of the limits of Impressionism, Monet painted, in 1886, two pictures of a young girl with a parasol that he called *Essais de figure en plein air* (*Sketches of Figures in the Open Air*). He seemed to accept – as he confirmed a few months later with his painting *En norvégienne* (*In the Norway Yawl*) – the dissolving of figures in light and thus rejected an idea still troubling his fellow Impressionists, that of the superiority of the human form over the landscape. Monet was prepared to go still further by ignoring the aesthetic quarrels that followed one another in quick succession from the end of the 1880s, by permanently abandoning the human form and becoming a landscape painter, by becoming absorbed in the representation of the instant. Instantaneity was the logical, if not only, conclusion of Monet's Impressionism, which he himself defined in 1890: "The more I paint, the more I see that I will have to work hard if I am to succeed in rendering what I am aiming at:

'instantaneity', especially the envelope, the same light over everything...". For the synoptic vision of his first landscapes Monet substituted an analytical vision that broke down light by means of a multitude of superimposed strokes in a dense, compact network. He invented the series – paintings of the same subject at different times of day and in different seasons – which revolutionised the art of landscape painting as much as the invention of perspective four centuries earlier. Several series, painted from 1891 onwards, bear witness to the painter's slow experiments: *Les Meules* (*The Haystacks*), *Les Peupliers* (*The Poplars*), *Les Bras de Seine* (*The Branches of the Seine*) and, of course, *Les Cathédrales de Rouen* (*Rouen Cathedrals*). The musée d'Orsay has the good fortune to be able to exhibit five of the twenty *Cathedrals* that make up this series. It was triumphantly exhibited at the Durand-Ruel gallery in 1895 and revealed the power of Monet's work, which never exhausts its subject but, on the contrary, modifies and strengthens it with each new canvas. Yet, with each subject chosen, the same question haunted his correspondence: "I am more and more obsessed by the need to express what I feel and pray to continue in good enough health, for it seems to me that I will make progress...".

They all shared the same obsession: to carry on painting and make as much progress as possible before the end. Caillebotte had died in 1894, Berthe Morisot in 1896. Caillebotte's death brought a master stroke in favour of Impressionism, the legacy of his collection to the State, which allowed the Impressionists to

force the doors of the musée du Luxembourg and later those of the Louvre. Another sign of the greater recognition accorded to Impressionism was the exhibition of Cézanne's work organised in 1895 by the dealer Vollard. Cézanne, the fiercest and most misunderstood of the Impressionists, "the ignorant dauber", won the respect of his peers. It was a chance to meet the Impressionists for the last time, not together but one after the other before Cézanne's works. Monet, Renoir, Pissarro and Degas bought paintings. Pissarro, Cézanne's former companion of the open air, wrote admiringly: "Wasn't I right in 1861, when Oller and I went to see the strange Provençal painter at the Académie Suisse, where Cézanne was painting nudes to the laughter of all the school's incompetents…" What everyone hailed in Cézanne's works was the powerful originality of his sensations, sensations captured thirty years earlier and which can be summed up as follows: "Let us read nature; let us realise our sensations in an aesthetic that is at once personal and traditional." *La Femme à la cafetière* (*Woman with Coffeepot*) and the studies for *Les Joueurs de cartes* (*The Card Players*), which seem to illustrate Cézanne's well-known precept, "show nature in the form of spheres, cones and cylinders", must not, however, make us forget the interest that the subject, whether portrait or genre painting, retains in the eyes of the artist.

Monet, Degas, Renoir and Cézanne pursued their research well into the 20th century. Sisley had died in 1899 and the work he left behind him often reflects that of Monet. The latter was to say of him: "He was equal to the greatest masters. I have seen again some of his works that are of a rare scope and beauty…". Pissarro died in 1903. In spite of very real differences, the work of the old painters has two things in common. The first is the concentration of subjects. Three or four themes, endlessly repeated, developed and enriched were now enough for the men who, a few decades earlier, had tackled their era in all its diversity and mobility. The second is a more distant and more classical interpretation of nature, in spite of a continuing study of reality and ceaseless work on the motif.

Renoir, who lived more often than not in the south of France, always worked with the greatest of pleasure, exclaiming: "It is so delicious to give oneself up to the pleasure of painting!" Despite moments of doubt, Renoir seems to have lived his last years in the flush of success, bringing back to life all the nymphs of antiquity and the 18th century.

Degas' situation was very different. He lived alone in Paris, the city that had always fascinated him, feared for his eyesight and almost went blind, but somehow always found the strength – as he himself confided: "Without work, it would be a sad old age!" – to explore the themes of dance and women at their toilette; these he renewed by a less ironical, more lyrical approach, and above all by an insatiable curiosity for the techniques he was trying out or had invented. Degas took photographs, touched up his prints, engraved, drew on his photographs and photographed his prints, returned to works begun years earlier, modelled, sculpted and

superimposed media and materials, as he had done for his *Petite Danseuse de 14 ans* (*Little Fourteen-Year-Old Dancer*) in the late 1870s. Finally the confirmed city-dweller, who despised and scorned the fashion for painting in the open air, discovered nature, and delivered landscapes with the intense colours and violent, almost abstract shapes of his last dancers.

Cézanne, too, lived in isolation. But his isolation was deliberate and cultivated in order not to waste time: "Isolation is all I deserve. At least no one can get their hands on me." And, like Monet, he added: "I make some progress every day, that's the main thing." Having retired to Aix-en-Provence, which he hardly ever left, Cézanne returned to the themes of his youth: portraits, still lifes, landscapes and bathing scenes. The man who in 1903 had written "I can see the Promised Land. Will I be like the great Hebrew leader or will I be able to enter it..." had become the prophet of modern art.

Monet's artistic legacy is as impressive as Cézanne's and many 20th-century artists claim his influence. The creation over a period of some thirty years (from 1897 until his death in 1926), of the *Nymphéas* (*Water Lilies*) cycle illustrates an entire work of art, from the creation of a subject, the water garden at Giverny, to that of a monumental pictorial environment that is both obsessive and calming. The *Nymphéas* decorations were given to the State by the painter and installed under his direction in the musée de l'Orangerie in a final gesture showing both his deep generosity and independence. In 1909, Monet stopped his painting trips to Norway, London and Venice and concentrated on his garden and water-lily pond. There he explored, in suffering or in peace, primordial nature; the nature of fullness, stifling and distressing, in the *Ponts japonais* (*Japanese Bridges*) and the nature of emptiness, infinite and serene, in the *Nymphéas bleus* (*Blue Water Lilies*).

Beyond these works, by turns playful and grave, it is in the years of searching, invention, enthusiasm and suffering that made up the lives of so many of these great painters that Impressionism retains its charm for us today, and will continue to do in the future.

Le Pont de Moret
(The Bridge at Moret)

1893 ▪ 73.5 x 92.5 cm

Alfred **Sisley** 1839 - 1899

In 1889, Sisley withdrew to Moret, near the forest of Fontainebleau, as always in the search for an affordable way of life and pleasant climate. There he devoted himself to the study of landscapes with a very provincial flavour still virtually untouched by industrialisation. He seems to have been charmed by the rustic architecture of the village and several times portrayed its little church, as Monet had the cathedral of Rouen. The depiction of the village bridge allowed him to compose a dynamic image. The bridge over the Loing forms a large oblique slant and the colours, which play on the contrast between the blue of the sky and the white of the houses, are particularly brilliant. In this sober, balanced composition executed in small, close brushstrokes Sisley seems to want to preserve, twenty years on, the Impressionism of the early days, in all its purity, integrity and ingenuousness, beyond the rifts and revolutions that the movement was now undergoing.

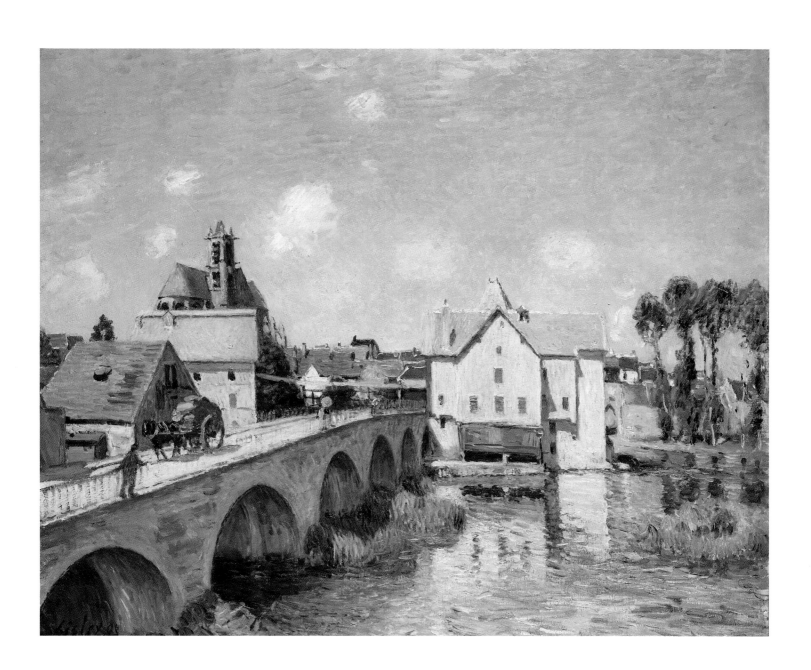

La Bergère, also known as *Jeune fille à la baguette*
(The Shepherdess, also known as *Young Girl with a Stick)*
1881 ▪ 81 x 64.7 cm ▪ 7th Impressionist exhibition, 1882

Camille **Pissarro** 1830 - 1903

At the start of the 1880s, Pissarro placed the human form at the heart of his preoccupations as a painter, constructing his landscapes as settings for the day-to-day lives of his models. In this, he was following the example of Jean-François Millet, whom he much admired. Millet had died in 1875 and his works were beginning to be appreciated by collectors. At the same time, Pissarro was actively engaged with Degas and his pupil Mary Cassatt in setting up a review of engravings entitled *Le Jour et la Nuit* (*Day and Night*), which may have influenced him in his choice of subjects. As a result of this, Pissarro, who was considered first and foremost an austere landscape painter, revealed a more human, poetical face. His artistic technique also underwent a change at this time. It was still just as rigorous in its constructions, but it became more luminous, more colourful and more lively. The novelist and critic Huysmans, who was devoted to the cause of humanity in the towns and countryside, hailed Pissarro's new works: "M. Pissarro can now be classed as one of our boldest and most remarkable painters. If he can keep such a perceptive, agile and subtle eye, he will certainly be the most original landscape painter of our time." Unfortunately, Pissarro's supporters were less appreciative of his new paintings. This phase of reconstruction of Pissarro's was very important to Gauguin in his early work and it resulted a few years later in his joining the neo-Impressionist movement started by the young Seurat, who knew Pissarro's work well and was just as influenced by Millet.

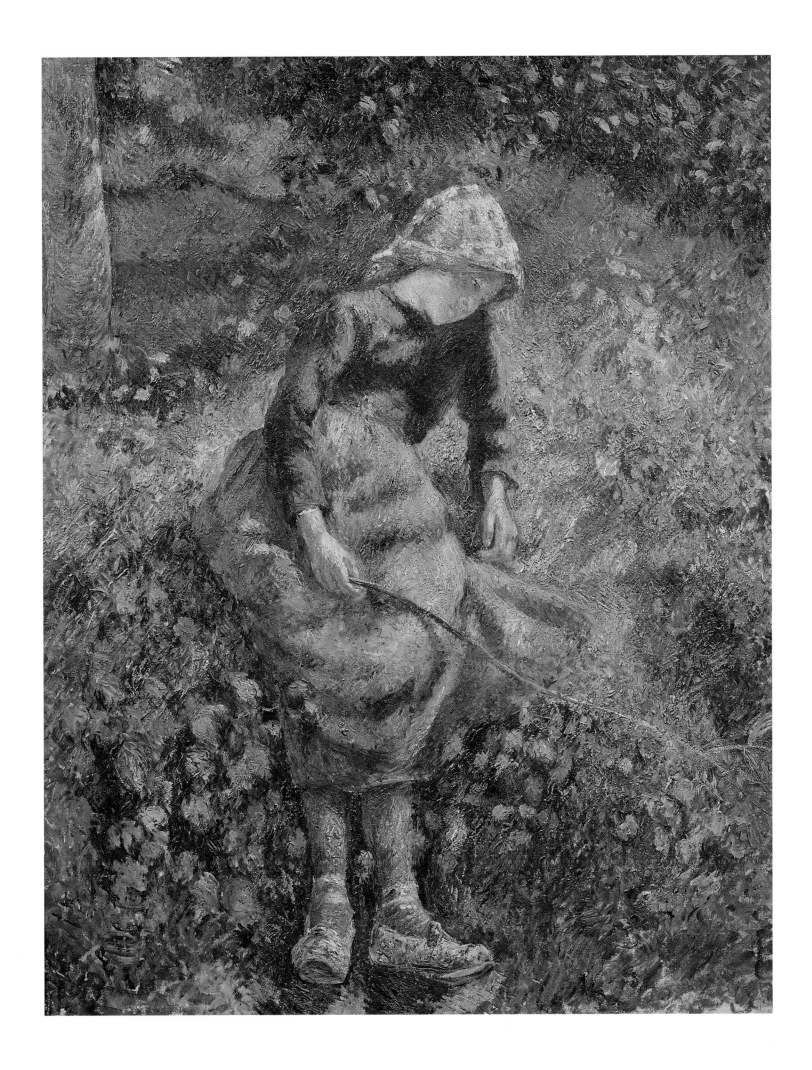

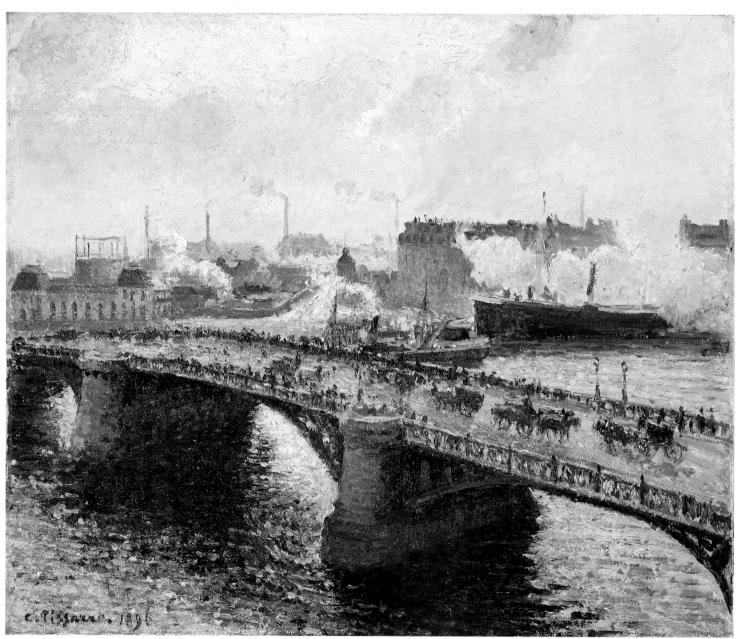

Camille **Pissarro** ▪ *Le Pont Boïeldieu à Rouen, soleil couchant, temps brumeux* (*The Boïeldieu Bridge, Rouen, at Sunset in Misty Weather*), 1896 ▪ 54 × 65 cm

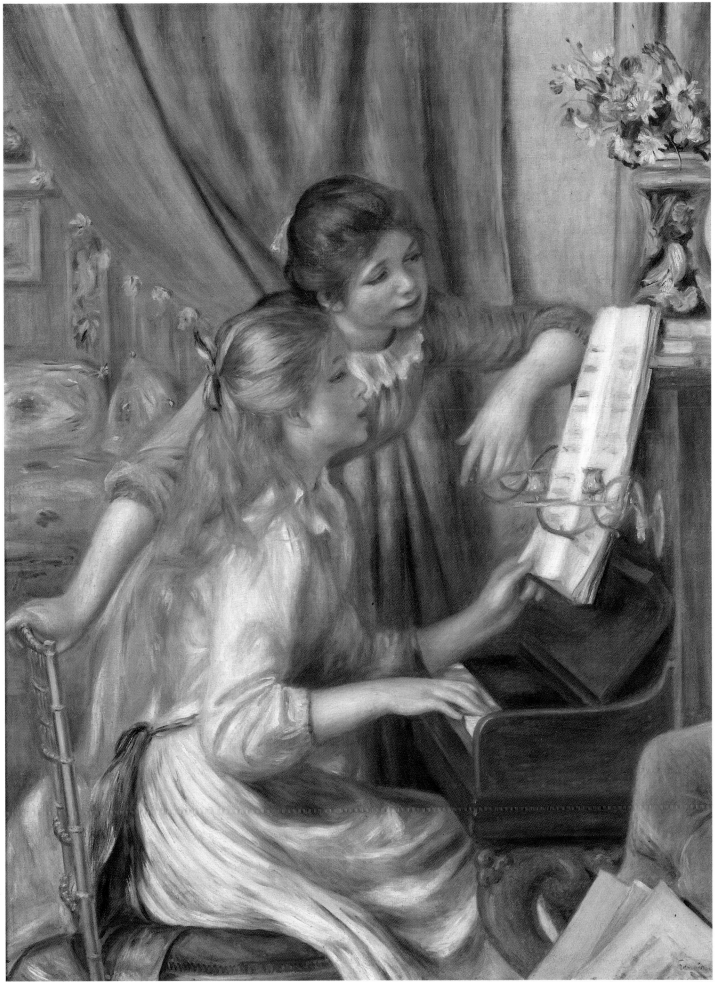

Pierre-Auguste **Renoir** ▪ *Jeunes filles au piano (Young Girls at the Piano)*, 1892 ▪ 116 × 90 cm

Les Baigneuses (The Bathers)

c. 1918–1919 ▪ 110 x 160 cm

Pierre - Auguste **Renoir** 1841 - 1919

Les Baigneuses, which Renoir painted at the very end of his life, is his pictorial testament. He painted relentlessly and wrote: "I'm perfectly happy and won't die before finishing my masterpiece." The subject of bathers appeared regularly in Renoir's work, especially at times when he was wondering about the direction his experiments should take. It was also a fundamental Impressionist theme, Manet having been the first, with his *Déjeuner sur l'herbe* (*The Luncheon on the Grass*), to explore the relationship between the nude and the landscape. Cézanne, with whom Renoir had always had a very friendly relationship, also devoted his last years to monumental bathers lacking any mythological or contemporary references. This is how Renoir saw his own women, whom he swelled with all the passion that their bodies inspired in him and inflated with all the health and strength that he had always revered. He abandoned himself unreservedly to his love of life, women's bodies and nature, perhaps in the hope that his countrymen at war and lost in the throes of civilisation and its dangers, would find in them a message of peace and tranquil communion with nature and the sun.

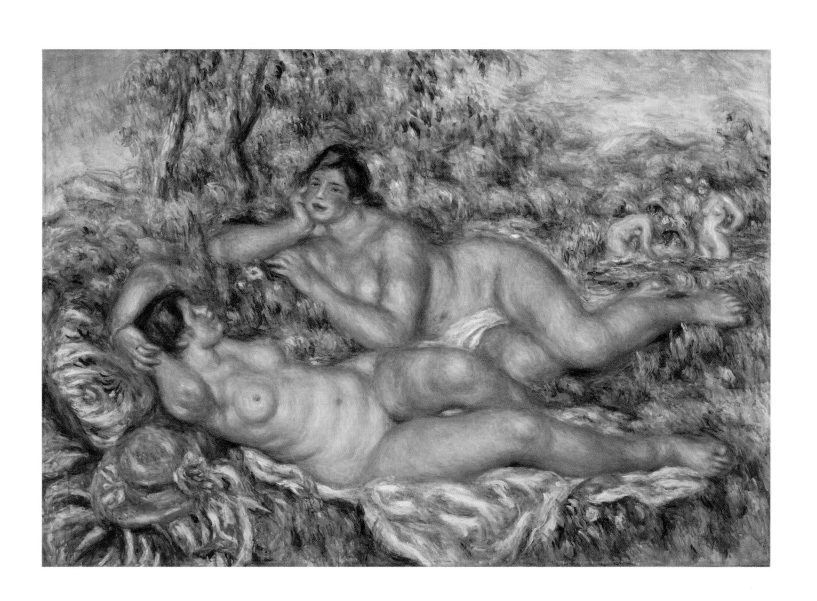

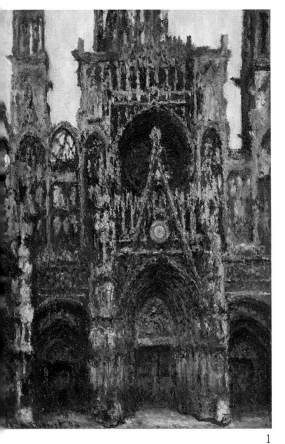

1

La Cathédrale de Rouen

1. *Rouen Cathedral. Main Door Seen from the Front. Harmony in Brown*
1894 ▪ 107 × 73 cm, Monet exhibition, Galerie Durand-Ruel, 1895

2. *Rouen Cathedral. Main Door, Morning Sun. Harmony in Blue*
1894 ▪ 91 × 63 cm, Monet exhibition, Galerie Durand-Ruel, 1895

3. *Rouen Cathedral. Main door in the Morning Light. Harmony in White*
1894 ▪ 106 × 73 cm, Monet exhibition, Galerie Durand-Ruel, 1895

4. *Rouen Cathedral. Main door in Full Sunlight. Harmony in Blue and Gold*
1894 ▪ 107 × 73 cm, Monet exhibition, Galerie Durand-Ruel, 1895

5. *Rouen Cathedral. Main door on a Dull Day. Harmony in Grey*
1894 ▪ 100 × 65 cm, Monet exhibition, Galerie Durand-Ruel, 1895

Claude **Monet** 1840 - 1926

Monet had to wage two campaigns, in 1892 and 1893, to complete the tremendous task of painting the cathedral of Rouen at different times of day. It was a terrible experience that haunted the artist day and night: "I had nightmares all night: the cathedral was falling on top of me and seemed blue or pink or yellow…". Monet set up his easel in three different places but always just a few yards from the cathedral, which entirely filled his field of vision. The continual proximity of the stone wall probably explains the obsessive nature of Monet's work. He had always complained about the slowness and difficulty of his task but it had never seemed such torture: "I struggle on and work…, leaving my canvases aside and going back to them according to the changes in the weather; it's mind-numbing work and very tiring." This monumental task was completed in the Giverny studio in the course of 1894 (which explains the dates of the paintings). Monet signed twenty *Cathédrales* and destroyed those that failed to satisfy him. The series was first shown at Durand-Ruel's at a private exhibition that opened on 10th May 1895. Pissarro wrote to his son: "His *Cathedrals* are going to be sent here and there, even though the series really needs to be seen as a whole… it's the work of someone strong-willed and level-headed pursuing the elusive nuances of effects that I have seen achieved by no other artist." And he later added: "I think the matter is so important that I've come on purpose." Monet did indeed revolutionise landscape painting in his ability to record the fleeting reflection of life and movement on a single, fixed subject, in this case one laden with history.

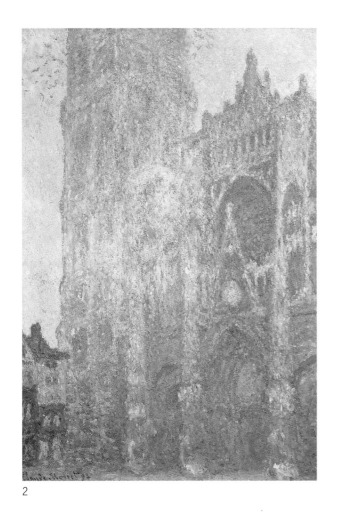

2

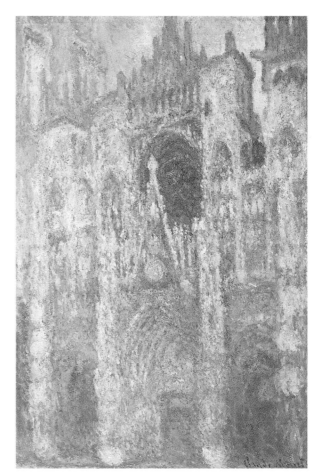

3

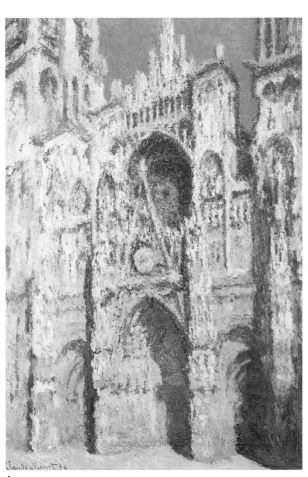

4

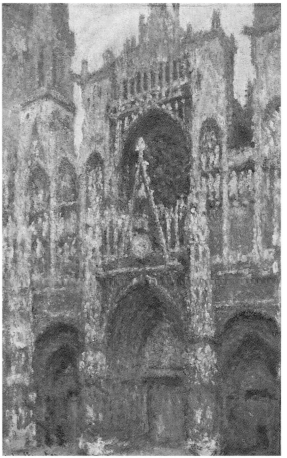

5

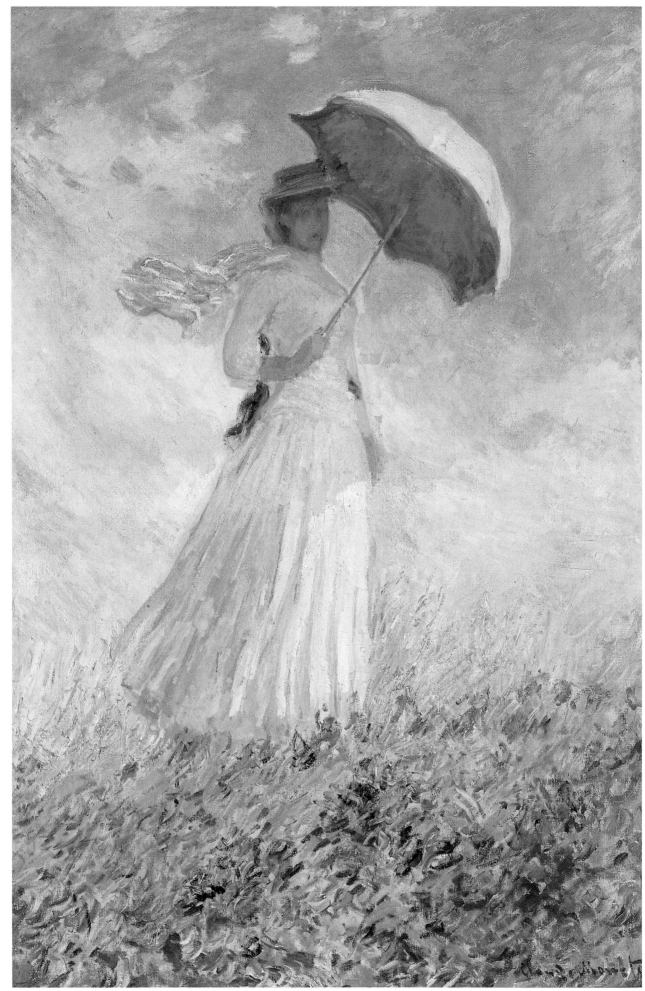

Claude **Monet** ▪ *Essai de figure en plein air : Femme à l'ombrelle tournée vers la droite* (*Sketch of a Figure in the Open Air: Woman with a Parasol Facing Right*), 1886 ▪ 131 × 88 cm ▪ Monet exhibition, Galerie Durand-Ruel, 1891

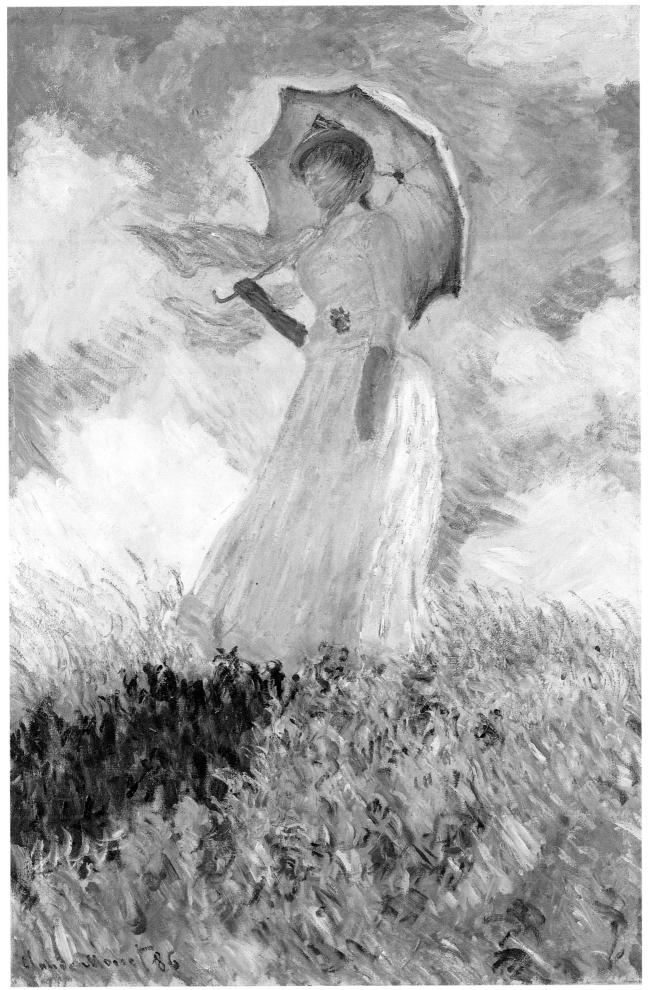

Claude **Monet** ▪ *Essai de figure en plein air : Femme à l'ombrelle tournée vers la gauche* (*Sketch of a Figure in the Open Air: Woman with a Parasol Facing Left*), 1886 ▪ 131 × 88 cm ▪ Monet exhibition, Galerie Durand-Ruel, 1891

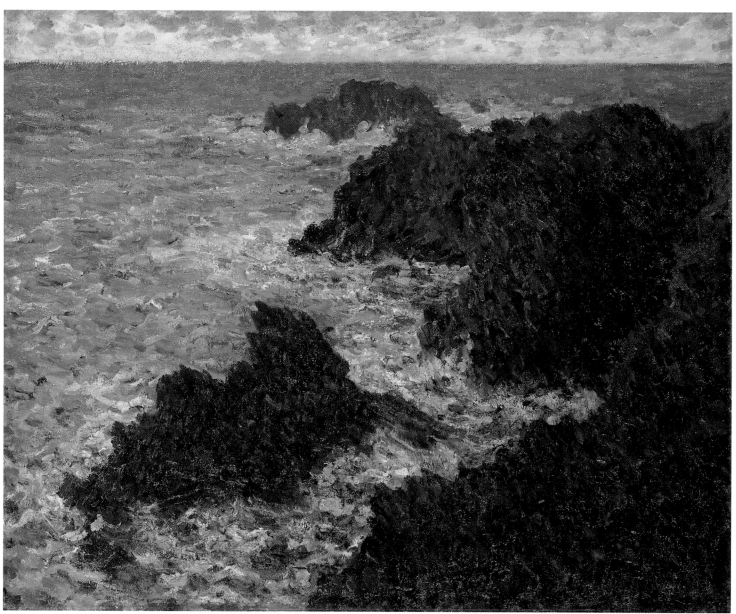

Claude **Monet** ▪ *Les Rochers de Belle-Île ; la côte sauvage* (*The Rocks of Belle-Île; the Wild Coast*), 1886 ▪ 65 × 81.5 cm

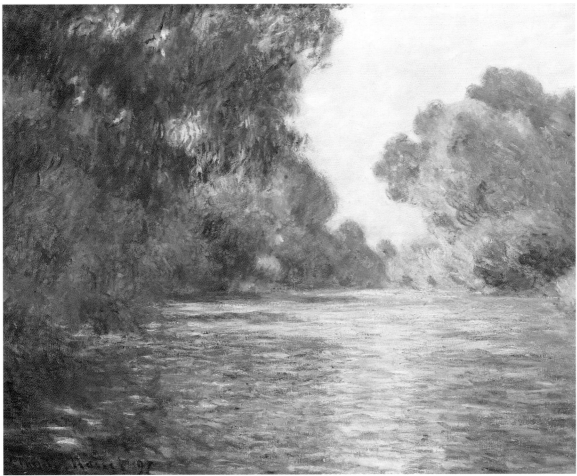

Claude **Monet** ▪ *Bras de Seine près de Giverny (Branch of the Seine near Giverny)*, 1897 ▪ 75 × 92.5 cm

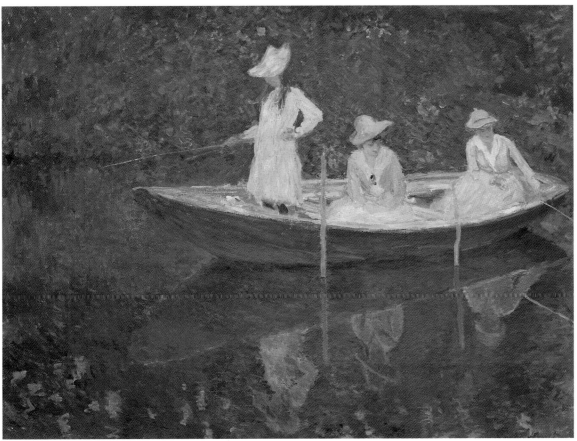

Claude **Monet** ▪ *En norvégienne* ou *La Barque à Giverny (In the Norway Yawl* or *The Boat at Giverny)*, c. 1887 ▪ 98 × 131 cm
▪ Monet–Rodin exhibition, Galerie George Petit, 1889

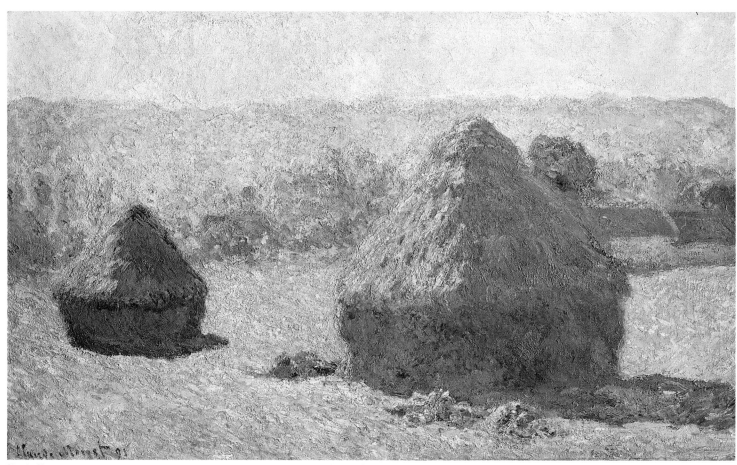

Claude **Monet** ▪ *Les Meules ; fin de l'été (The Haystacks; Late Summer)*, 1891 ▪ 60.5 × 100.5 cm ▪ Monet exhibition, Galerie Durand-Ruel, 1891

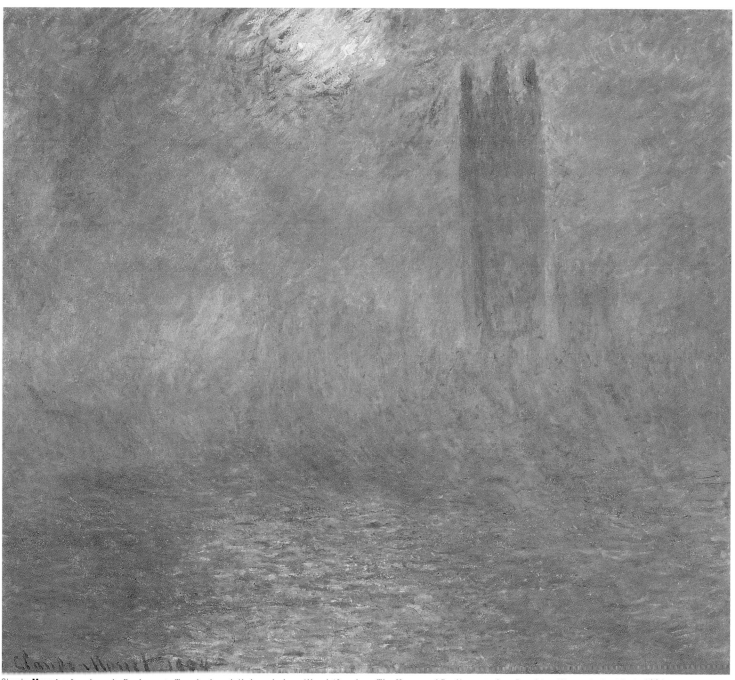

Claude **Monet** ▪ *Londres, le Parlement. Trouée de soleil dans le brouillard (London, The Houses of Parliament. Sun Breaking Through the Mist)*, 1904 ▪ 81 × 92 cm ▪ Monet exhibition, London, 1904

La Femme à la cafetière
(Woman with Coffeepot)
c. 1890–1895 ▪ 130.5 x 96.5 cm

Paul **Cézanne** 1839 - 1906

La Femme à la cafetière is one of the major works by Cézanne housed at the musée d'Orsay. It ushers in a long series of anonymous portraits of humble people – a gardener, a "poacher" and country folk – that Cézanne was working on from the early 1890s alongside the more official portraits of his dealer Vollard, and the critics Gasquet and Geoffroy. Its monumentality and frontality are reminiscent of the portrait *Achille Emperaire* painted around 1868 and marked by the influence of Manet. But, with his portraits of the 1890s, Cézanne demonstrates that he is no longer indebted to anyone. The entire composition of *La Femme à la cafetière* is made up of a subtle interplay of balance and imbalance. Nothing seems stable in the scene with its strongly marked but decidedly sloping lines. Yet the whole work conveys a static impression. The artist's point of view seems to change according to whether he is looking at the woman's face or hands, the table, the cup, the coffeepot or the perfectly erect teaspoon. This can also be seen in Cézanne's large still lifes, such as the *Nature morte aux oignons (Still Life with Onions)* or *Pommes et Oranges (Apples and Oranges)*. Such strictly geometrical paintings have often led people to believe that Cézanne treated his models the same way as the objects in his still lifes. The dealer Vollard's recollections of the painter's interminable, exhausting sittings have confirmed that he demanded of his models the same immobility as the apples or statuettes. Yet, behind the stern features of *La Femme à la cafetière*, and behind her rough hands, we can discern Cézanne's humanity and respect for lives of labour.

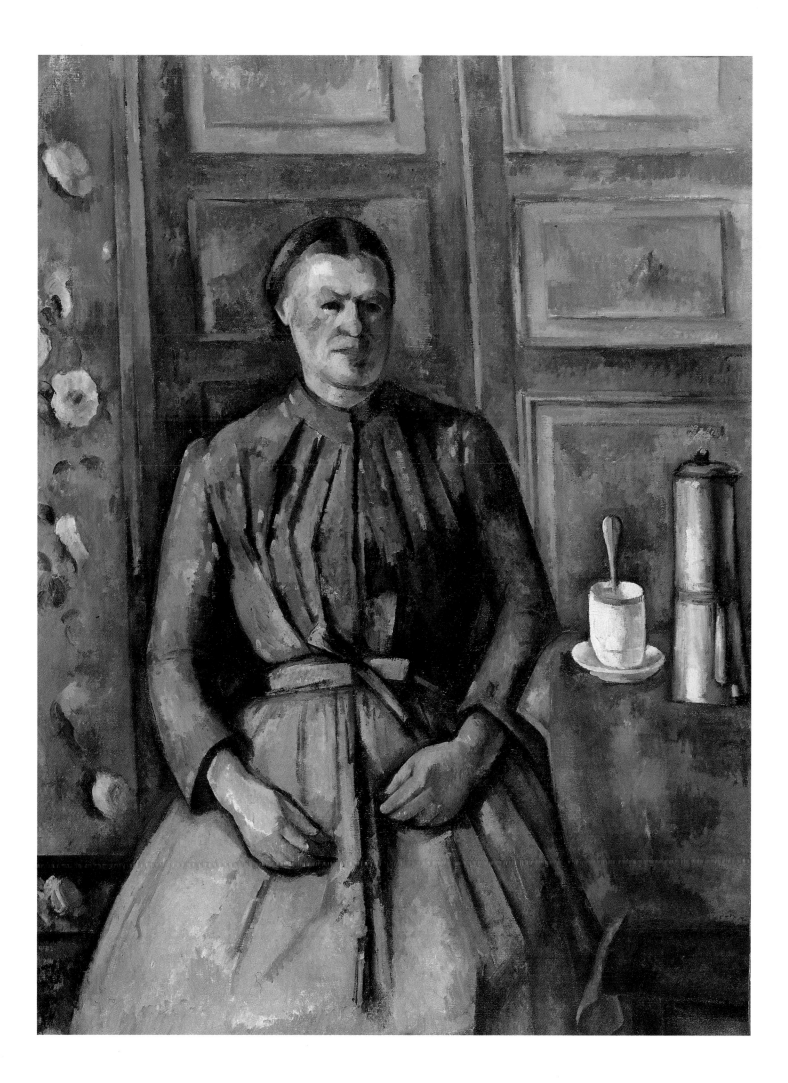

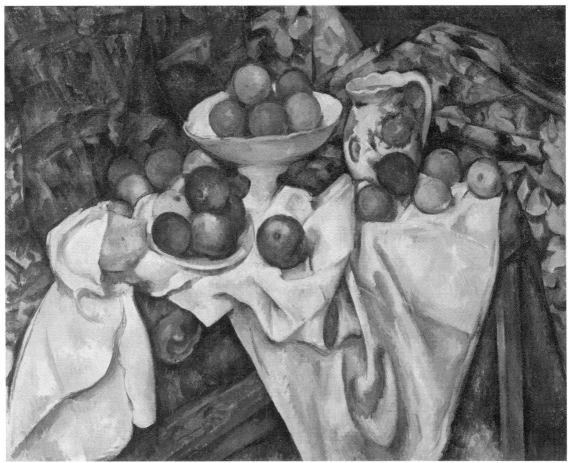

Paul **Cézanne** ▪ *Pommes et oranges (Apples and Oranges)*, c. 1895–1900 ▪ 74 × 93 cm

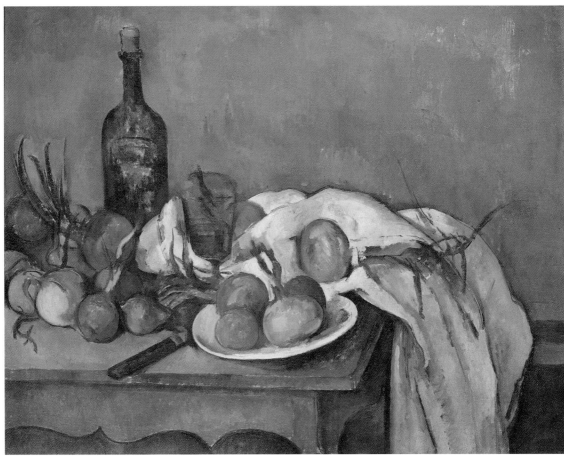

Paul **Cézanne** ▪ *Nature morte aux oignons (Still Life with Onions)*, c. 1895 ▪ 66 × 82 cm

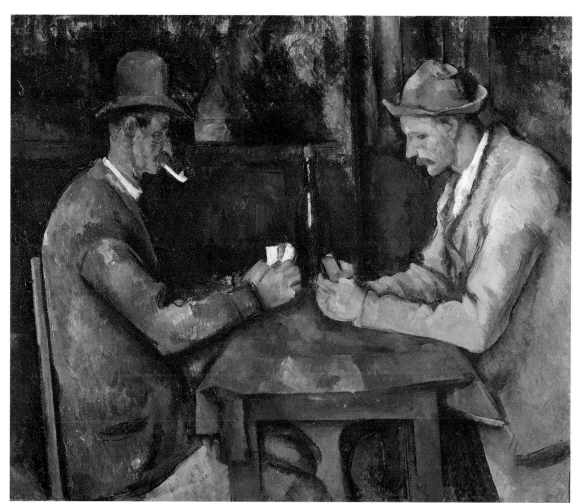

Paul **Cézanne** ▪ *Les Joueurs de cartes (The Card Players)*, c. 1890–1895 ▪ 47.5 × 57 cm

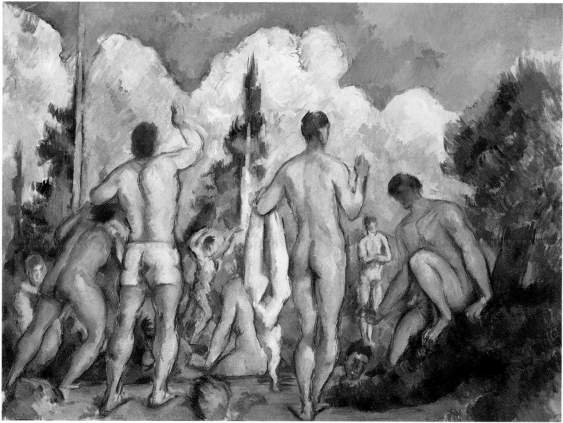

Paul **Cézanne** ▪ *Baigneurs (Men Bathing)*, c. 1890–1892 ▪ 60 × 82 cm

Danseuses bleues (Blue Dancers)

c. 1893 ▪ 85 x 75.5 cm

Edgar **Degas** 1834 - 1917

Dancers were important to Degas. They appeared throughout his career and followed the painter's development year after year. At first graceful and fleeting, they later came to symbolise the vices of Parisian life of the 1870s and 80s, before coming to translate Degas' new lyrical inspiration in their suspended gestures at the end of the 1880s. Degas' colours then became more intense, pervading the very titles of the paintings, as in *Danseuses bleues* and *Danseuses roses* (*Pink Dancers*). The artist's usually clear features gradually become blurred by colour and a desire to erase the everyday accessories of dance. Whereas Degas had sometimes pushed realism to the limits of scientific investigation, as in *La Petite Danseuse de 14 ans* (*Little Fourteen-Year-Old Dancer*), the scene here bathes in an indecision accentuated by the framing, which was perhaps directly inspired by the photographs with which Degas, a very amateur photographer, was in the habit of working. While the last years of his career may once have seemed obscure, we now realise how good he was at renewing his experiments as a result of his interest in techniques (photography, wax and plaster, monotypes, pastels and *vernis*), in colour, which he rediscovered when working on landscapes in particular, and in the endless invention of the moving human body.

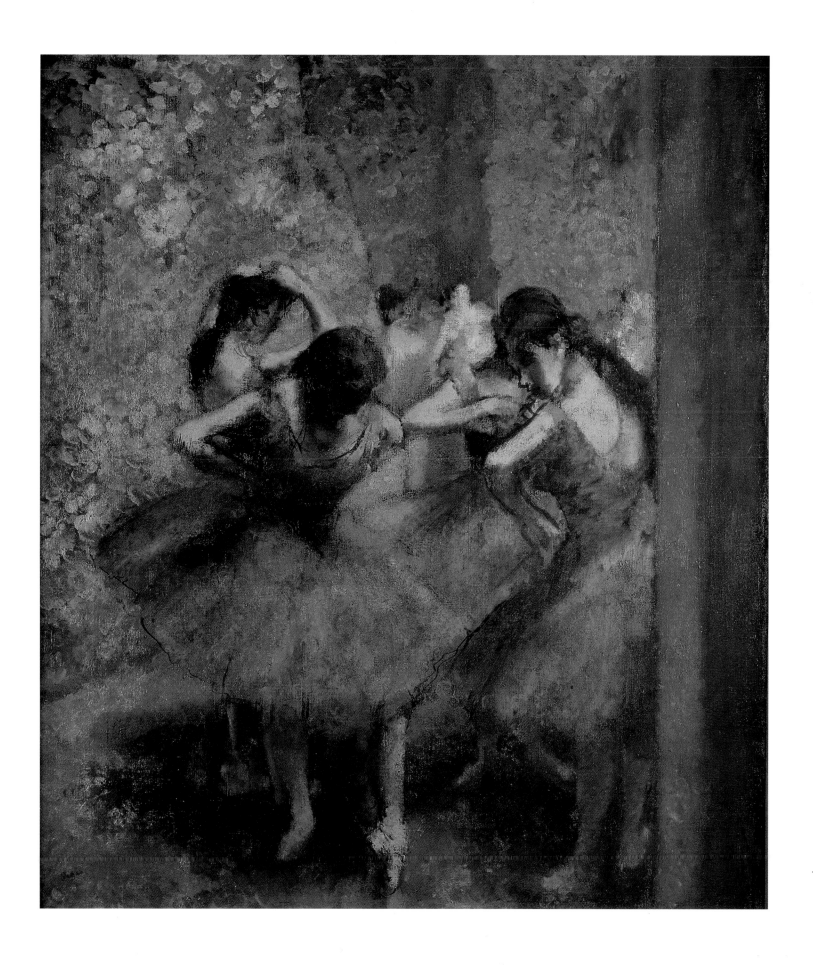

Le Bassin aux nymphéas ; harmonie verte
(The Water-Lily Pond; Green Harmony)

1899 ▪ 89 x 93.3 cm ▪ Monet exhibition, Galerie Durand-Ruel, 1900

Claude **Monet** 1840 - 1926

In 1883, Monet moved to Giverny. Ten years later, he acquired some land on which he had a pool dug that was to form the centrepiece of his water garden. In 1897, he formulated for the first time the idea of a decoration totally inspired by the surface of his pool dotted with water lilies. The project was abandoned but later restarted, changed and amplified. In 1918, the old painter decided to give his series of decorations to the French State and, on his death, after thirty years' hard work, twenty-two panels were installed in the Orangerie of the Tuileries, which was specially fitted out to receive them. The *Water-Lily* cycle constitutes a complete work of art (from the creation of a subject to a monumental and multiform decorative series) since Monet painted some three hundred pictures on the same theme. The cycle is made up of several large families. One of them, to which this painting belongs, consists of views of the pond and its water lilies, to which Monet has added sections of bank with a variety of plants, as well as the Japanese bridge in the background. This highly decorative series was shown with some success at the gallery of Durand-Ruel, Monet's main dealer, in 1900. It describes a profuse, complex space in which two spaces, the real and the reflected, overlap. These two worlds, which are actually one and the same and constantly echo each other, are still treated with a certain naturalism that gradually gives way to an infinite, primordial universe.

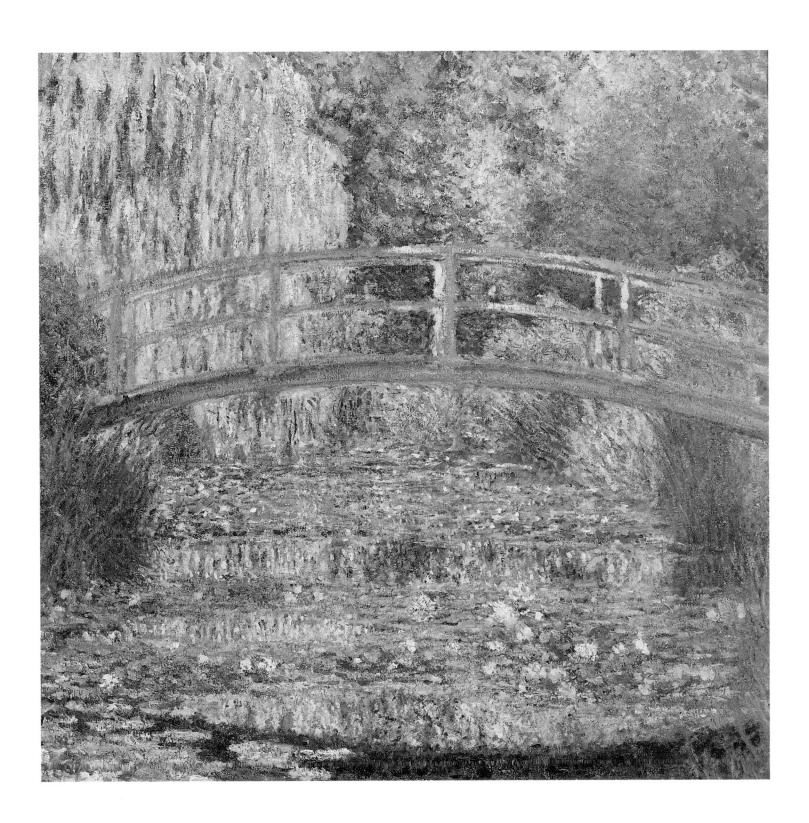

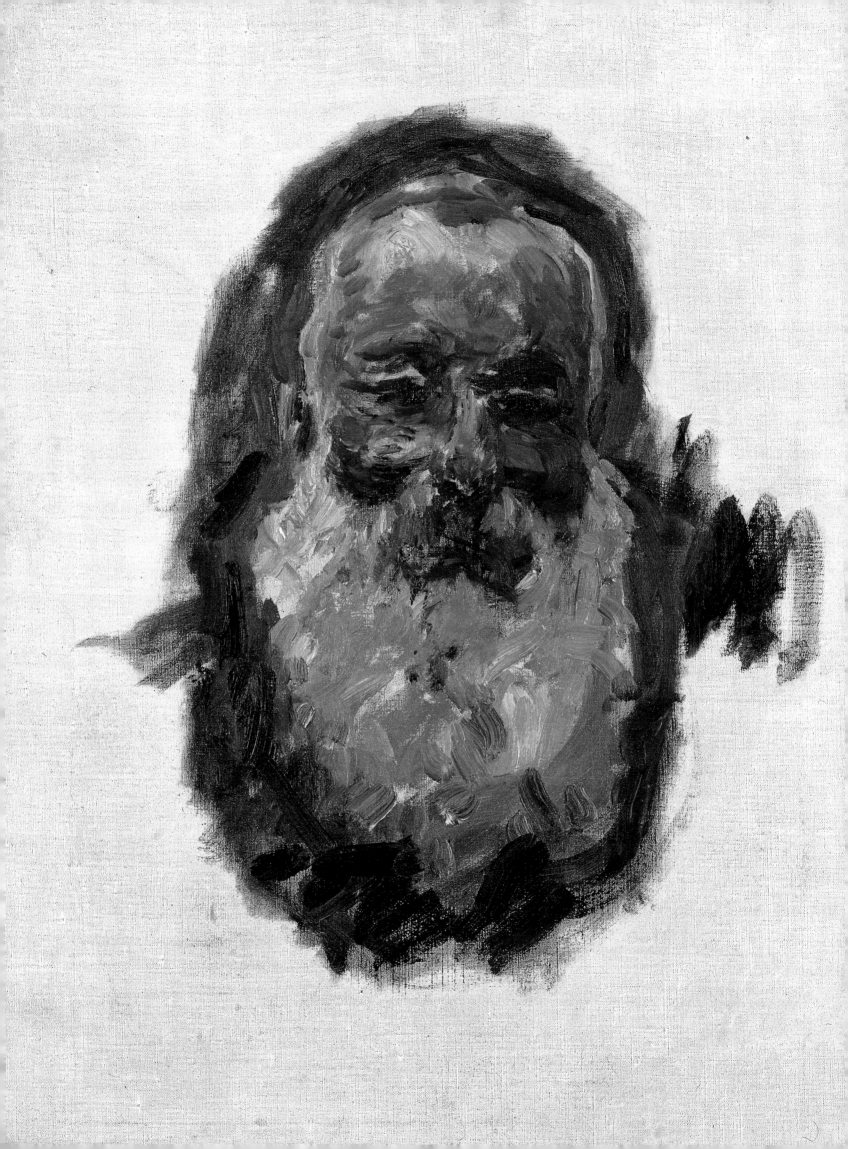

Biographies

- FRÉDÉRIC **BAZILLE**
- GUSTAVE **CAILLEBOTTE**
- PAUL **CÉZANNE**
- EDGAR **DEGAS**
- ÉDOUARD **MANET**
- CLAUDE **MONET**
- BERTHE **MORISOT**
- CAMILLE **PISSARRO**
- PIERRE-AUGUSTE **RENOIR**
- ALFRED **SISLEY**

Left: Claude **Monet** ▪ *Portrait de l'artiste (Portrait of the Artist)*, 1917 ▪ 70 × 55 cm

Frédéric ▪ Bazille

Montpellier, 1841 – Beaune-la-Rolande, 1870

In 1862, Frédéric Bazille, the son of an upper-middle-class provincial family, went to Paris to study medicine. He entered the studio of Charles Gleyre and made the acquaintance of Monet, and later Renoir and Sisley. He rented several studios in succession and gradually won the acceptance of his artistic vocation by his parents. With his fellow artists, to whom must be added Pissarro and Cézanne, he planned to organise an independent exhibition of the group in 1867. He bought Monet's *Femmes au jardin* (*Women in the Garden*) the same year. When France declared war on Prussia, Bazille joined the Zouaves and was killed at the battle of Beaune-la-Rolande on 28th November.

"The great Bazille did something very fine: a little girl in a very pale dress in the shade of a tree behind which you can see a village. There is a lot of sun and light. He tried to do what we have so often tried, to paint a figure in the open air; this time, it seems to me that he has succeeded..." Berthe Morisot, 1869.

"In any case, work at it and be demanding of yourself, for in Paris they definitely credit us with more talent than we have..." Letter from Monet to Bazille, 1867.

Gustave ▪ Caillebotte

Paris, 1848 – Petit-Gennevilliers, 1894

In 1876, Gustave Caillebotte joined the Impressionist group after studying with the academic painter Léon Bonnat. Caillebotte, who had a vast fortune, devoted a lot of time and energy to organising the group's exhibitions and bought works at a time when the artists were finding it more and more difficult to sell them. The legacy of his collection continues this generous action aimed at securing the group's recognition. However, this should not make us overlook the strength and originality of an artist who played an active part in realism with works such as the *Raboteurs de parquet* (*Planing the Floor*).

"Caillebotte died suddenly... Here was one we can mourn for he was kind and generous and, on top of that, a painter of talent." Pissarro.

"I give all the paintings I possess to the State, but as I want this gift to be accepted, and in such a way that the paintings are not consigned to the attic or a provincial museum but to the Luxembourg and later the Louvre, a certain amount of time must go by before this clause is executed, until the public not necessarily understands but accepts this style of painting." Caillebotte's will.

Paul ▪ Cézanne

Aix-en-Provence, 1839 – Aix-en-Provence, 1906

Cézanne was the son of a banker who gave him a small allowance that allowed him to study painting in Paris. In 1862, he frequented the Académie Suisse, where he met Pissarro. At the Café Guerbois, he met up with Zola, his childhood friend, who had become the defender of Manet and the small group of future Impressionists. From 1872 to 1874, he worked a great deal with Pissarro and took part in the Impressionist exhibitions of 1874 and 1877. After 1882, he became more and more isolated. In 1895, the exhibition devoted to him by Vollard revealed his solitary work, which was much admired by painters. The Salon d'Automne organised a posthumous retrospective of his work in 1907, which confirmed him as the father of modern painting.

"Why is it that you never mention Cézanne, that not a single one of us recognises him as one of the most surprising and curious characters of our times and one who has had a very great influence on modern art?" Letter from Pissarro to Huysmans, 1883.

"I hope that Cézanne will still be here and that he will join us, but he is so strange and so afraid of seeing new faces... He is a true artist and has come to have far too many doubts about himself..." Letter from Monet to Geoffroy, 1894.

Edgar ▪ Degas

Paris, 1834 – Paris, 1917

Degas was the son of a Parisian banker. In 1855, he entered the École des Beaux-Arts but soon left since his family situation allowed him to stay for long periods in Rome and Italy without the benefit of the Prix

de Rome. From 1865 onwards, Degas became more and more interested in modern subjects and, in 1870, he published an article on the conditions for hanging works at the Salon. He then became an active organiser of the Impressionist exhibitions in which, in the face of the landscape painters, he defended realist, urban subjects. From 1886 onwards, he lived and worked in semi-isolation and assembled an exceptional collection of old and new works that he planned to turn into a museum.

"Degas isn't enough of a painter, he hasn't got what it takes..." Cézanne.

"If Degas had died at the age of fifty, he would have left behind the reputation of an excellent painter, but no more. His work opens up after the age of fifty and he becomes Degas." Renoir.

Edouard · Manet
Paris, 1832 – Paris, 1883

Before he entered Couture's studio in 1850 to learn to paint, Manet, a judge's son, wanted to be a sailor. In 1859, he was refused by the Salon but, in 1861, his *Chanteur espagnol* (*The Spanish Singer*) was shown at the Salon and awarded a medal. For two years, he had increasingly unpleasant experiences of the Salon, where his works often caused a scandal: the scandal of *Le Déjeuner sur l'herbe* (*The Luncheon on the Grass*) in 1863, at the Salon des Refusés, the scandal of *Olympia* in 1865... While Manet organised a private exhibition of his works with the support of Zola's lively pen in 1867, he refused to join his Impressionist friends in the exhibitions of their group, with which his name was nevertheless linked by the critics. A studio artist, he tried open-air painting with Monet in the summer of 1874, and at that time adopted a lighter technique. The presence of his friend Antonin Proust in the government of 1881 earned him a semblance of official recognition but his death in 1883 robbed him of wider success.

"... in the opinion of the great majority of people interested in French painting, Édouard Manet's role was useful and decisive. He not only played a major individual role, but was also the representative of a great and fertile evolution..." Letter from Monet to the minister responsible for the gift of *Olympia* to the State in 1890.

"I did not know Baudelaire but I knew Manet..." Cézanne.

"Manet was as important to us as Cimabue and Giotto were to the Italians of the Renaissance" Renoir.

Claude · Monet
Paris, 1840 – Giverny, 1926

Monet, the son of a small shopkeeper, spent his childhood in Le Havre, where he tasted the joys of the sea. In 1860, he joined the bohemian realists gathered round Courbet and later entered Gleyre's studio, where he met Renoir, Sisley and Bazille. His meeting with Boudin and Jongkind, and the advice they gave him, played an even more important part in his development. He could count on very little help from his family and soon became acquainted with the sometimes unpleasant artistic milieu on which artists depended: the Salon, the dealers and the art lovers. In 1874, he became the head of the company organising the first Impressionist exhibition and fought for its independence. Having lived through some very difficult years from 1878 to 1882, Monet moved to Giverny, gradually becoming the greatest French landscape painter and never ceasing to reinvent the relationship between the artist and nature until his death.

"Who is this Monet who seems to be using my name and who has come here to take advantage of my renown?" Manet, 1865.

"Yes, a man like Monet is fortunate; he has accomplished his destiny." Cézanne.

"The sky is blue, isn't it? And it was Monet who found that out." Cézanne.

Berthe · Morisot
Bourges, 1841 – Paris, 1895

Berthe Morisot began her study of painting with several artists, and in particular Corot, but it was her meeting with Manet, at the Louvre in 1868, that was decisive. She became his pupil and favourite model but, unlike him, she linked herself with the Impressionists and exhibited with them. In 1874, she married Manet's brother and, until her death, sought with him to preserve the friendship between the various members of the group.

"…she was so intelligent and so talented that I cannot stop thinking about her" Letter from Monet on the death of Berthe Morisot.

"That's what I was coming to: her eyes. They were almost too large and so very dark that Manet painted them black in several of her portraits instead of the greenish colour they really were in order to capture all their mysterious force and magnetism." Valéry.

Camille ▪ **Pissarro**
Saint-Thomas, 1830 – Paris, 1903

Pissarro began his artistic apprenticeship in Paris in 1855. After he met Corot, he devoted himself to open-air painting. In 1859, he frequented the Académie Suisse, where he saw Monet and later, in 1861, Cézanne. During the war of 1870, he was with Monet in London, where they visited the museums together. From 1872 to 1874, he worked with Cézanne in the countryside around Pontoise and Auvers. In 1874, he took part in the first Impressionist exhibition and was the only artist to take part in all eight of them. Pissarro formed a link between Impressionism and the younger generation, and Signac, Gauguin, Matisse and others sought his advice.

"As for old Pissarro, he was like a father to me. He was a man you could consult and something of a god" Cézanne.

"Pissarro's landscapes are like angels going to market" Degas.

"Pissarro was such a good teacher that he could have taught stones to draw properly" Mary Cassatt.

"Pissarro was a very nice man – he was like one of the prophets on the Well of Moses in Dijon" Matisse.

Pierre- ▪ **Renoir**
Auguste ▪ Limoges, 1841 – Cagnes-sur-mer, 1919

Initially tempted by painting on porcelain, Renoir finally devoted himself to painting and entered the Gleyre studio in 1862, where he frequented Bazille, Monet and Sisley. Encouraged by Monet, he painted in the open air and worked beside him in 1869 at La Grenouillère. In 1874, he took part in the group's first exhibition at Nadar's but returned to the Salon in 1879. Out of loyalty to his friends and his dealer Durand-Ruel, he showed his *Le Déjeuner des Canotiers* (*The Luncheon of the Boating Party*) (Washington, Philips Collection) at the sixth Impressionist exhibition of 1881. In the early 1880s, Renoir went through a period of reconstruction, which involved an affirmation of his drawing. The end of his life was marked by a return to a broader, freer, more lyrical style, which led to the success of his many nudes.

"Though Degas sometimes said of Renoir's work, 'He paints with balls of wool', meaning he found the latter's painting a little fluffy, at others he could be heard to exclaim before one of Renoir's canvases that he was lovingly caressing: 'Oh! What lovely work!" Vollard.

Alfred ▪ **Sisley**
Paris, 1839 – Moret-sur-Loing, 1899

In 1862, the Englishman Sisley entered Gleyre's studio and made the acquaintance of Monet, Renoir and Bazille. His father's fortune secured for him a carefree start in life but the war of 1870 soon put a stop to that. Sisley began to exhibit his work at the Salon as Corot's pupil but took part in the first Impressionist exhibition of 1874. He quickly moved away from the capital and in 1882 made a permanent home at Moret-sur-Loing. Until his death, he was unhappy not to be as successful as his friends Monet and Renoir and bitterly considered himself to be the "tail-end of Impressionism".

"He is a truly great artist and, in my opinion, second to none…" Pissarro.

"Sisley is perhaps less daring than Monet and may not have so many surprises in store for us but, on the other hand, he does not linger along the way, as sometimes happens with Monet, trying to render effects so fleeting that he does not have time to capture them." Duret.

Chronology

1863 * Salon des Refusés. Manet shows *Le Déjeuner sur l'herbe* (*The Luncheon on the Grass*).

1867 * Personal exhibitions organised by Courbet and Manet on the occasion of the Universal Exhibition. Attempt at a common exhibition by Bazille, Monet, Renoir and Sisley.

1870 * Franco-Prussian war. Defeat of France. End of the Second Empire. Proclamation of the Third Republic. Degas and Manet take part in the defence of Paris. Cézanne takes refuge at l'Estaque, Monet and Pissarro in London. Bazille is killed at the battle of Beaune-la-Rolande.

1871 * Paris Commune.
Return of Monet and Pissarro.

1874 * First Impressionist exhibition in the studio of the photographer Nadar, boulevard des Capucines.

1876 * Second exhibition of the group at the gallery of the dealer Durand-Ruel.

1877 * Third Impressionist exhibition.

1879 * Fourth exhibition of the group. Renoir exhibits at the Salon.

1880 * Fifth Impressionist exhibition without Monet, Sisley and Renoir, who preferred to exhibit at the Salon.

1881 * The State leaves the organisation of the annual Salon to the artists. Sixth Impressionist exhibition.

1882 * Durand-Ruel, with the help of Caillebotte, organises the Seventh Impressionist exhibition with works by Monet, Sisley and Renoir. Cézanne is admitted to the Salon for the first time thanks to the support of his friend Guillemet.

1883 * Death of Manet. Monet has moved to Giverny. He stays with Renoir in Provence.
They visit Cézanne.

1886 * Eighth and last Impressionist exhibition. Cézanne inherits his father's fortune.

1888 * Durand-Ruel opens a gallery in New York. His success in the American art market saves the business.

1890 * Monet starts a fund to buy *Olympia* from Manet's widow and give it to the State.

1891 * Monet's first series, *Les Meules* (*The Haystacks*) is exhibited at Durand-Ruel's.

1894 * Death of Caillebotte. His collection is bequeathed to the State.

1895 * Exhibition of the *Cathédrales de Rouen* (*Rouen Cathedrals*) at Durand-Ruel's and first Cézanne retrospective at Vollard's.

1899 * Death of Sisley.

1903 * Death of Pissarro (and Gauguin).

1906 * Death of Cézanne.

1914 * Start of the First World War.

1917 * Death of Degas.

1918 * End of the war.
Monet gives the "large decorations", the *Nymphéas* (*Water Lilies*), to the State.

1919 * Death of Renoir.

1926 * Death of Monet.

1927 * Inauguration of the Orangerie of the Tuileries, in Paris, with the *Nymphéas* (*Water Lilies*) arranged according to Monet's instructions.

List of illustrations

Frédéric **Bazille** (1841–1870)
L'Atelier de la rue de la Condamine, 19. *Réunion de famille*, 43. *La Robe rose* or *Vue de Castelnau-le-Lez*, 42.

Gustave **Caillebotte** (1848–1894)
Les Raboteurs de parquet, 95.

Mary **Cassatt** (1844–1926)
Femme cousant, 65.

Paul **Cézanne** (1839–1906)
Achille Emperaire, 48. *Baigneurs*, 133. *L'Estaque, vue du golfe de Marseille*, 84. *La Femme à la cafetière*, 131. *Les Joueurs de cartes*, 133. *La Madeleine* or *La Douleur*, 29. *La Maison du pendu*, 80. *Nature morte à la bouilloire*, 27. *Nature morte aux oignons*, 132. *Pastorale* or *Idylle*, 28. *Les Peupliers*, 85. *Pommes et oranges*, 132. *Le Pont de Maincy*, 83. *Portrait de l'artiste*, 81. *La Tentation de saint Antoine*, 107. *Une moderne Olympia*, 104.

Edgar **Degas** (1834–1917)
Le Champ de courses. Jockeys amateurs près d'une voiture, 101. *Dans un café*, also known as *L'Absinthe*, 93. *Danseuses bleues*, 135. *Le Défilé*, also known as *Chevaux de course devant les tribunes*, 37. *La Famille Bellelli*, 41. *Le Foyer de la danse à l'Opéra de la rue Le-Peletier*, 38. *L'Orchestre de l'Opéra*, 39. *Petite danseuse de 14 ans*, 99. *Portraits à la Bourse*, 97. *Repasseuses*, 96. *Répétition d'un ballet sur la scène*, 100. *Scène de guerre au Moyen Âge*, 24. *Sémiramis construisant Babylone*, 24.

Henri **Fantin-Latour** (1836–1904)
Un atelier aux Batignolles, 20.

Édouard **Manet** (1832–1883)
Le Balcon, 45. *Berthe Morisot au bouquet de violettes*, 21. *Clair de lune sur le port de Boulogne*, 55. *Le Déjeuner sur l'herbe*, 23. *Émile Zola*, 47. *L'Évasion de Rochefort*, 103. *Le Fifre*, 44. *Olympia*, 25. *La Serveuse de bocks*, 88. *Stéphane Mallarmé*, 105. *Sur la plage*, 54.

Claude **Monet** (1840–1926)
Le Bassin aux nymphéas; harmonie verte, 137. *Bras de Seine près de Giverny*, 127. *La Cathédrale de Rouen, le portail vu de face.*

Harmonie brune, 122. *La Cathédrale de Rouen, le portail, soleil matinal. Harmonie bleue*, 123. *La Cathédrale de Rouen, le portail et la tour Saint-Romain, effet du matin. Harmonie blanche*, 123. *La Cathédrale de Rouen, le portail et la tour Saint Romain, plein soleil. Harmonie bleue et or*, 123. *La Cathédrale de Rouen, le portail, temps gris. Harmonie grise*, 123. *Coquelicots*, 73. *Les Déchargeurs de charbon*, 96. *Le Déjeuner ; panneau décoratif*, 71. *Le Déjeuner sur l'herbe*, 33. *Les Dindons*, 73. *En norvégienne* or *La Barque à Giverny*, 127. *Essai de figure en plein air : Femme à l'ombrelle tournée vers la droite*, 124. *Essai de figure en plein air : Femme à l'ombrelle tournée vers la gauche*, 125. *Femmes au jardin*, 32. *La Gare Saint-Lazare*, 87. *Grosse mer à Étretat*, 54. *Hôtel des Roches Noires. Trouville*, 31. *Londres, le Parlement. Trouée de soleil dans le brouillard*, 129. *Madame Louis-Joachim Gaudibert*, 49. *Les Meules; fin de l'été*, 128. *La Pie*, 53. *Portrait de l'artiste*, 138. *Régates à Argenteuil*, 34. *Les Rochers de Belle-Île ; la côte sauvage*, 126. *La Rue Montorgueil, à Paris, Fête du 30 juin 1878*, 89. *Train dans la campagne*, 35.

Berthe **Morisot** (1841–1895)
Le Berceau, 63.

Camille **Pissarro** (1830–1903)
La Bergère, also known as *Jeune fille à la baguette*, 117. *Coteau de l'Hermitage, Pontoise*, 77. *Gelée blanche*, 79. *Le Pont Boïeldieu à Rouen*, 118. *Portrait de l'artiste*, 78. *Printemps. Pruniers en fleurs*, 85. *La Route de Louveciennes*, 52. *Les Toits rouges, coin de village, effet d'hiver*, 84.

Pierre-Auguste **Renoir** (1841–1919)
Alphonsine Fournaise, 68. *Les Baigneuses*, 121. *Bal du Moulin de la Galette, Montmartre*, 91. *La Balançoire*, 67. *Chemin montant dans les hautes herbes*, 68. *Danse à la ville*, 69. *Danse à la campagne*, 69. *Étude. Torse, effet de soleil*, 66. *Frédéric Bazille*, 20. *Le Jeune garçon au chat*, 25. *Jeunes filles au piano*, 119. *La Liseuse*, 64.

Alfred **Sisley** (1839–1899)
L'Inondation à Port-Marly, 72. *La Neige à Louveciennes*, 72. *Le Pont de Moret*, 115. *Les Régates à Molesey*, 75.

James Abbott McNeill **Whistler** (1834–1903)
Variations en violet et vert, 51.

Photoengraving: Offset Publicité, Paris
Printing: Editoriale Lloyd, Italy
October 2001
Dépôt légal: September 1999